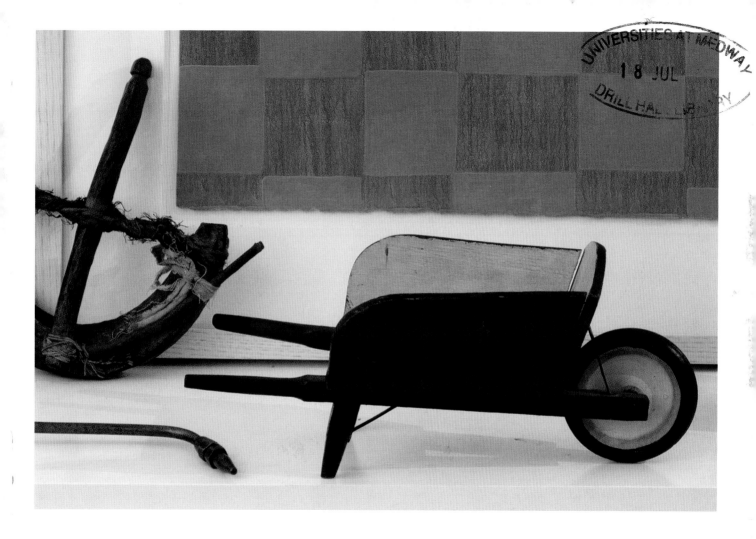

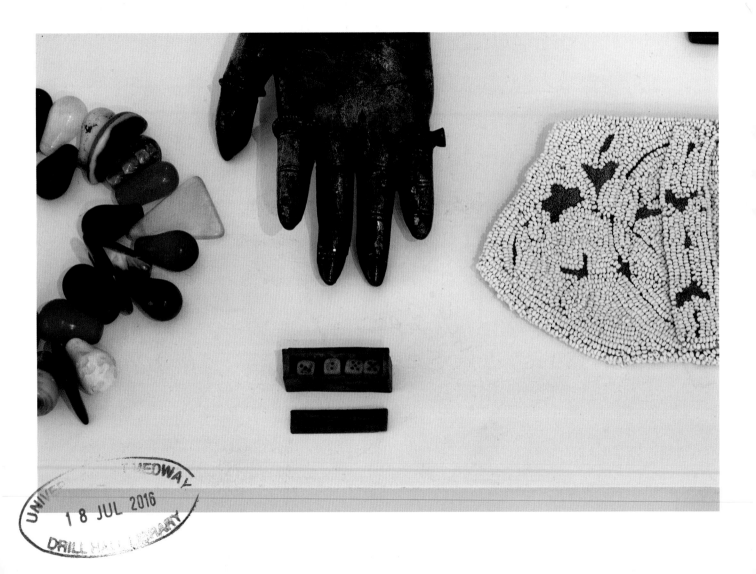

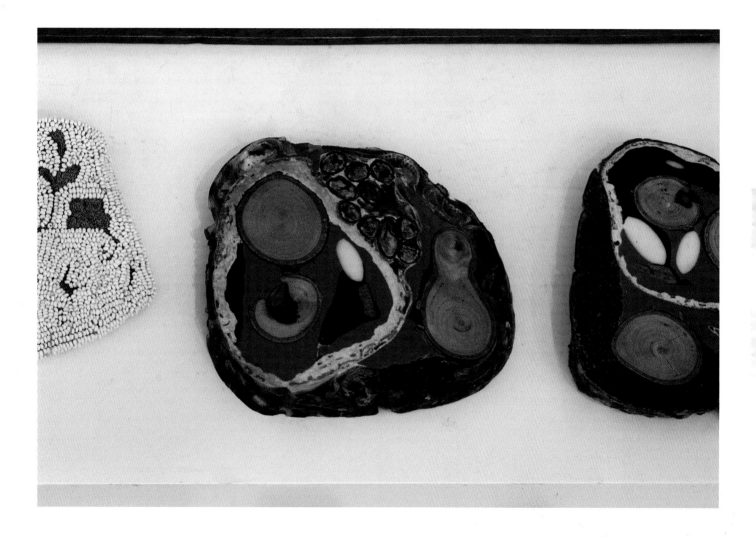

Wunderkammer

Tod Williams and Billie Tsien

Yale University Press

New Haven and London

Contents

Introduction

The objects that we cherish tell stories about who we are. We are interested in what other people collect, especially if the collection is idiosyncratic—an odd and various assortment. It is the variety that is intriguing. When the collection is broad, what is the thread of curiosity or wanting that ties them together and brings them under one roof? We have always been fascinated by the phenomenon of the Wunderkammer, or cabinets of curiosities, which arose in Renaissance Europe as repositories for all kinds of wondrous and exotic objects. Ranging from elegant rooms in the castles of kings to stuffed basements discovered after a collector dies, the Wunderkammer is a deeply personal statement. Even as we are entranced by the individual objects, it is more interesting for us to try to decipher the personalities of the people from the things that captivated them.

As I look around our own apartment, I see that one trait uniting many of Tod's and my things is that they show the hand and touch of the maker. There is a Zulu hat that is both an abstract red circle and the actual hair of a person. I see Peruvian stone carvings of cattle and pigs in corrals, small enough to fit in the palm of your hand, that were symbols of dowry exchanges. A red toy wheelbarrow found in a Michigan junk shop, the words HANDCRAFT C.H.K. 1946 penciled on its base, sits near a stool, carved in the shape of an animal, from the Dogon tribe in Mali. A small beaded deerskin bag appears to be Native American, but a hand-embroidered label tells us that the beads were strung and sewn in Belgium. Right next to that is a necklace of trade beads from Africa that are made from glass blown in Bohemia (now the Czech Republic). A box the size of a large splinter is filled with tiny, tiny dice, and I wonder whether it is a toy or something carried by a sailor on his voyages.

Interspersed with these objects that speak of other lives and other places are objects that speak of other times. These are mostly natural things: amber with insects, the broken tusk and tooth of a mastodon, fossils of fish, and sober stones that reveal their secret florid identities under black light.

I suppose we could say that we are looking for ourselves and we are looking for something outside ourselves. We want to affirm our own importance in the universe and to feel connected to a greater whole. Objects are our ballast. They help to keep us grounded. They make us feel secure in our own histories. They are chosen by intuition and curated and ordered in ways that answer only to our own wandering logic.

Billie and I share the same love of things, but she is an integrally ordered person. Basically, I am a disordered person who admires order. My mother, who encouraged systematic collections of butterflies, stamps, and coins, was appalled by my erratic and messy ways, and she would clean out my room when I was at school. I still recall my feeling of devastation when I found, at age three, that she had stuffed my beloved, nearly life-size Raggedy Ann doll into the backyard incinerator.

My fantasy, which is slowly wearing off as our collections grow, is of having a vast warehouse packed with things. I suppose our office, although it is not vast, may serve that purpose. I revel in the messy presence of things when I sense that they have a latent power, meaning, or spirit. I want them around; it's an almost pathological hoarding instinct. Americans like me, with little sense of family history, have this instinct. It is perhaps one reason why vast swaths of farmland are turning into storage shed cemeteries—the automobile salvage yards of the past.

This is why I have secret places in my heart for John Soane, the Collyer brothers, Ray and Charles Eames, Charles Moore, Alexander Girard, Henry Mercer, and Dr. Albert C. Barnes. The line between collector and hoarder is a thin one. Neither hoarding nor collecting necessarily denotes creativity, but in each there is a desire to be surrounded by things. It is curiosity that is the unifying quality of a creative mind.

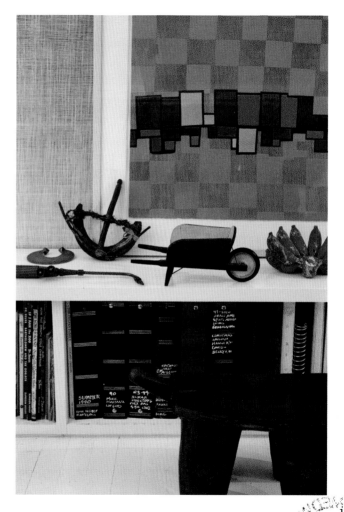

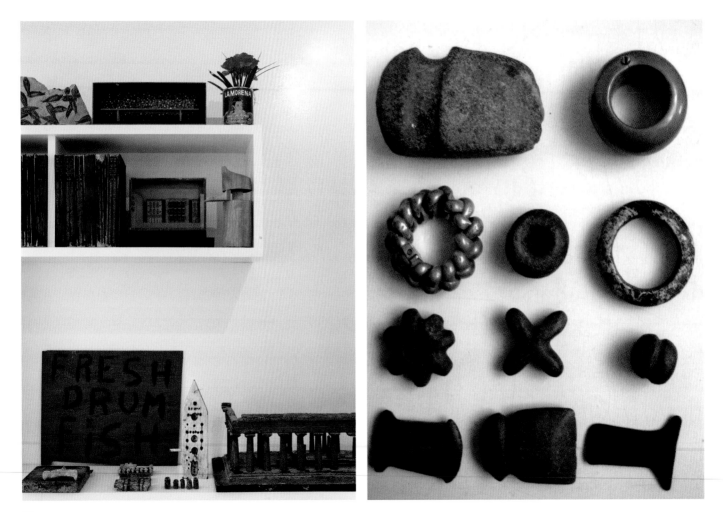

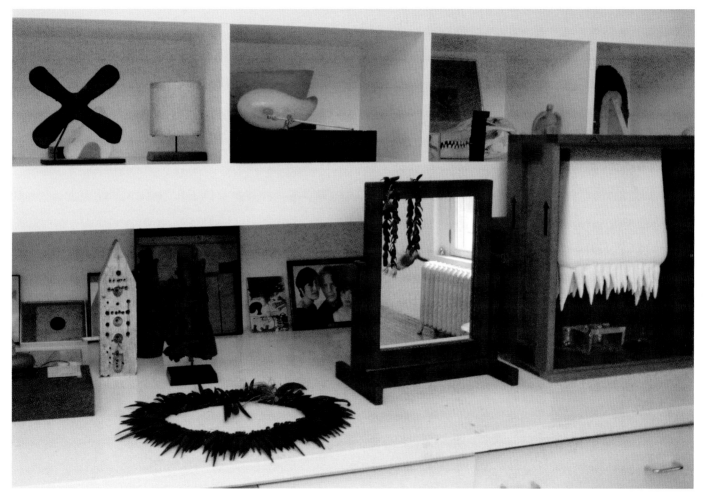

Common Ground

In January 2012 we were invited by David Chipperfield, a British architect, to participate in the 13th International Architecture Exhibition at the Venice Biennale. The Architecture Exhibition has been held every two years since 1980 at the Corderie dell'Arsenale and surrounding gardens. With each biennale a curator is selected to determine a theme and choose architects from around the world to participate by making installations and showing projects. David told us that the theme for the upcoming biennale was "common ground" and that his interest was in seeing what unites us as architects, designers, and human beings. "Architecture has become a sort of exotic fruit," he said in an interview with the *Guardian*. "It just sort of happens in certain places where it gets watered. The more it becomes a special thing, the less chance we have to deal with it on a day-to-day basis. What architecture is and how it fits into the community is a story I want to tell. . . . If we can deal with the common ground [in] the profession then maybe we can deal better with common ground between all professions." David's theme speaks to our studio's philosophy. We have written that "we see architecture as an act of profound optimism. Its foundation lies in believing that it is possible to make places on earth that can give a sense of grace to life." What we do is based on the belief that architecture is a service with the potential to be noble. We work as a family in our studio, and we trust the hands and knowledge of those who build. To us, common ground was a beautiful idea.

In responding to David's invitation we thought that we would add to his list of invitees with one of our own, essentially broadening his landscape. We would make our exhibition a room of quiet, separated from the intensity and bustle of the Biennale. The contents of the room would not be architectural projects but the fabric of the lives of our friends. As architects we are almost always "thing" people, curious and engaged in the physical world. As much as we use digital tools, we still crave things to touch. So we decided to ask thirty-five friends—architects, designers, writers, craftsmen, curators, and artists—to fill a box with objects that inspire them. We asked that they not include anything directly related to their work. We wanted to see if there was a thread that united us through the objects we love. We wanted to open a door to their minds without the need for words.

Our first idea was to build the very walls and furniture using the boxes themselves. Through the personality and texture of what was placed in the boxes there would be detail and warmth, and perhaps even that connecting thread that was our own common ground. In this way David's idea of a common ground would spread, branching ever outward to include those who went before us and those who will succeed us . . . a physical manifestation of our own DNA.

David also invited us to site our project in the Arsenale building. Having participated in the 2008 Architecture Exhibition, we knew that presenting our piece in the main hall of the Arsenale would be a formidable assignment. The building may be one of the largest exhibition spaces in the world. Entered from one end, its massive extruded interior requires a response that is large in scale, powerful in appearance, and clear in concept. Such a project requires the manual labor of many people, a huge expenditure of time, and a vast sum of money, which often leads to precisely the kind of overblown response that common ground was attempting to avoid.

Yet even as we imagined our good intentions for commonality, our first instinct was to be competitive, and we chose a very prominent location

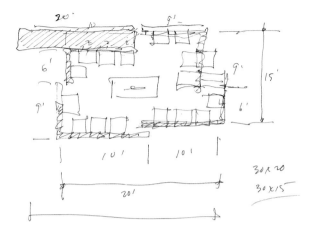

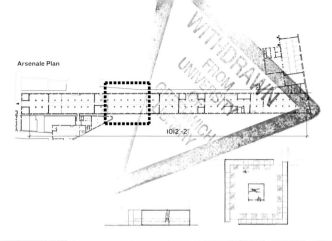

Arsenale Plan

1012'-2"

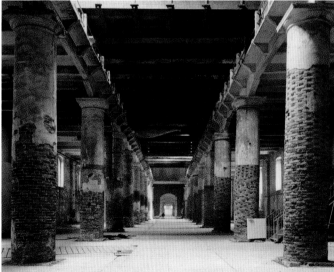

for our project. As we sketched out our project though, we soon realized that a room formed by boxes the size of suitcases would very likely be lost among the throngs. So we went back to David and asked for something smaller, more intimate, perhaps not so central but with strong character.

Casa Scaffali

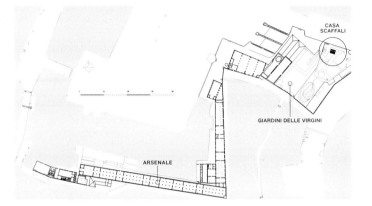

A few days later we were shown pictures of Casa Scaffali, the "house of shelves." This small shed had for years been used to house seeds and gardening equipment on the shelves lining its interior. It sits at the very farthest reaches of the Arsenale grounds, in the Giardini della Virgine (the Garden of the Virgins). In all our visits we had never ventured so far back. In fact Casa Scaffali had only recently been used for the Art Biennale, and never for an architecture exhibit. Another intention behind David's idea was to animate this least visited corner of the Biennale grounds. We were astonished by the photographs of what appeared to be a huge bush. Once there we found a small structure almost engulfed in vines and shrubbery. At first we were unsure whether it was a building at all. But it was a building in hiding, and the perfect place to hide the secrets we had asked our friends to share.

As Casa Scaffali's shelves were sturdy and battered through years of use and painted an ordinary gray, we tailored the boxes to the size and color of the shelves. One of the first people we asked to participate was a great friend of ours, the consummately skilled cabinetmaker Stephen Iino. We asked him to make the thirty-five boxes 20 × 40 × 12 inches deep. Each box had the name of the recipient stenciled on the side, and we both signed our names in one corner. The box was to become both the system of shipping and the site for each cabinet of curiosity.

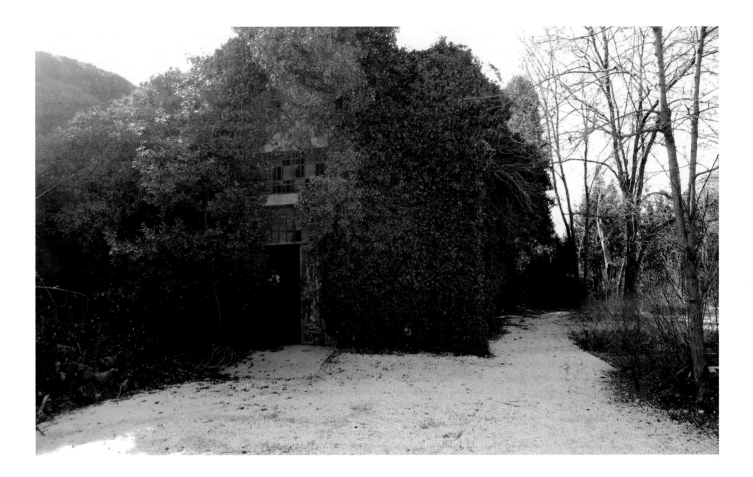

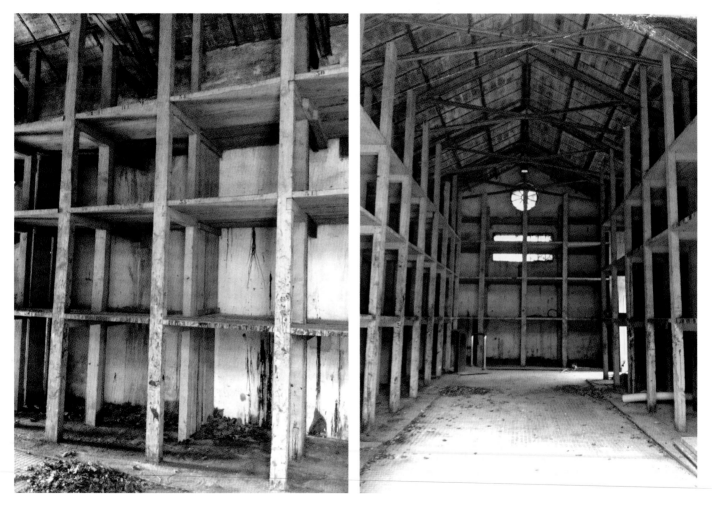

It needed to be sturdy enough to take at least three trips by air or ship, covering many thousands of miles (in one case thirty thousand miles), from its place of origin to the individual participant, then to Venice, and eventually back to its owner. We knew the box would bear its own history: the character and palimpsest, the marks, dings, and shipping labels of its individual journey.

Five days before the opening of the exhibition we arrived in Venice with a small crew: Aurelie Paradiso, a formidable and talented architect from our studio who shepherded this project; Stephen Iino and his wife, Toby Miroff; our son Kai Williams and his business partner, Chen Chen; a young architect, Daisy Ames; and the two of us. It was hot and humid, and mosquitoes were swarming. We had been told that the boxes would be open and resting on the shelves. Instead, there were thirty-four boxes in a pile covered with a sheet of pink plastic. We carried them one by one into the courtyard outside the Casa Scaffali and slowly, carefully opened them up. This is what we found.

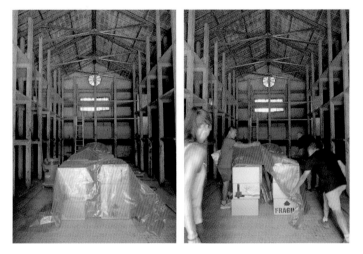

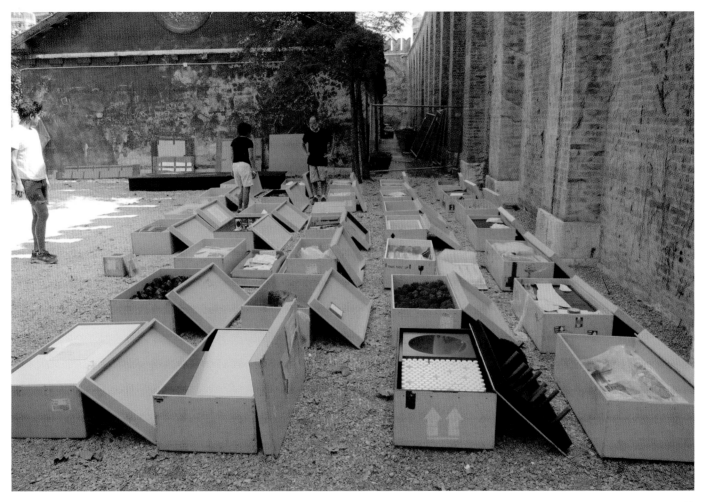

People have asked us what we would have put into our own box.

Certainly each of our own boxes would be very different. We chose instead to think of Casa Scaffali as our shared box.

We filled the box with
people who were our teachers and mentors
and people we taught and mentored
people for whom we worked
and people who worked for us
people who inspire us
people who amaze us
people we love
friends
That is what is in our box.

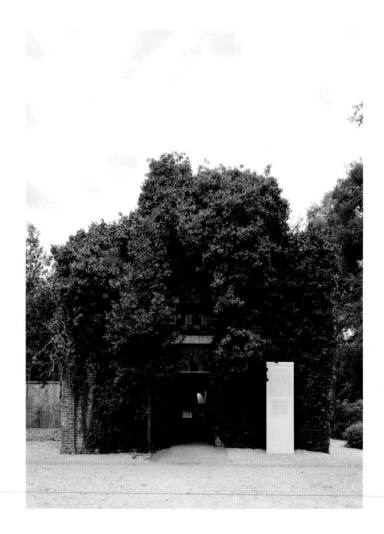

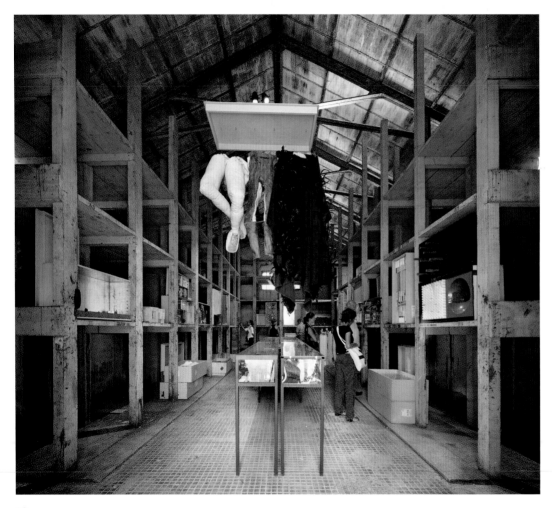

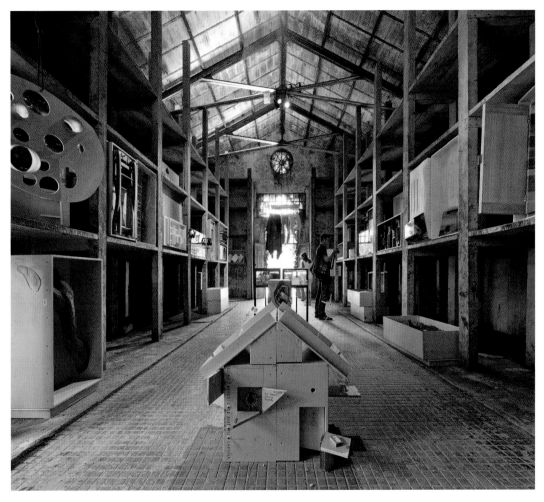

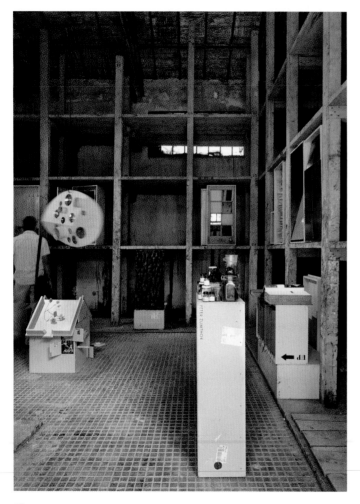

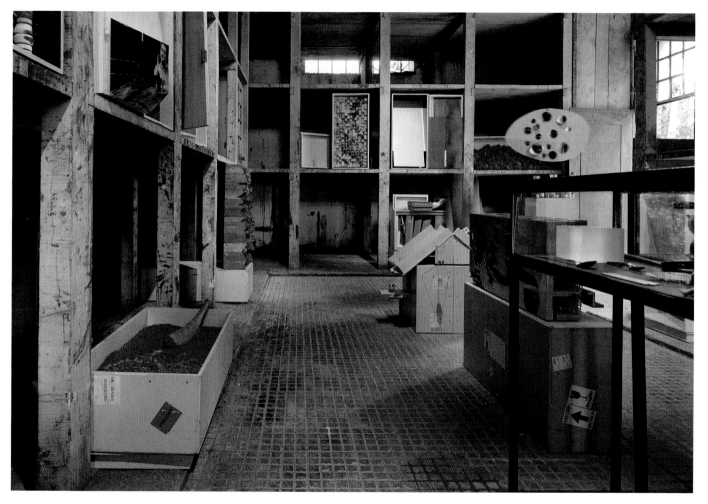

SHRINE TO THE
THINGS I WOULD LIKE
TO DONATE MORE OF
MY REMAINING DAYS

FOOLS GOLD BURN GOLD LEAF
FRANKINCENSE DRONE

SHRINE TO THE
THINGS I WANT TO
SPEND MY REMAINING.

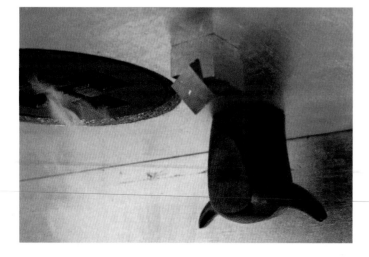

Men (whom many scholars believe originated from the small town of Ana, Iraq, on the Euphrates River, where my own father was born). The ancients also believed that pyrite promoted stronger communication between the left and right hemispheres of the brain. Between matter, logic, rationality, ego, future, and the past (the left side of the brain), and spirit, awareness, intuition, and the present moment (the right side of the brain).

This oscillating, shimmering, quivering reflection back and forth between EGO and SPIRIT, between MASS and LIGHT, between DARK MATTER and WHITE SMOKE, LOGIC, and INTUITION is precisely where all private creation resides. I hoped to create a shrine that manifests that journey of transformable creative ENERGY and "visions," the unexplored space that exists between the right and left hemispheres of our own brains.

THE BULL
Well, I'm just really mesmerized by the bull these days. DARK, MASSIVE, HEAVY, MASCULINE . . . surrounded by an endless space created by THIN, FRAGILE, SHIMMERING sheets of gold and that just felt good to me.

Marwan Al-Sayed

Los Angeles

A shrine of sorts. A space of reflection and meditation on something a good Indian friend of mine once said to me, casually yet profoundly:

FORM IS NOTHING
BUT CONDENSED
SPACE

SPACE IS NOTHING
BUT THINNED-OUT
FORM

Most of my workdays are filled with the chatter of minutiae: returning calls, emails, attending meetings, scheduling, traveling, etc., to the point that it seems the creative work has to always fight for airtime, for oxygen.

Therefore, I thought my box should hold space for reflection on the deepest, most inaccessible and mysterious aspects of creativity. Thoughts outside of time and place, projects, and procedures.

(ANCIENT) FORM

In thinking about FORM AS CONDENSED SPACE, I first thought of a MASS, A CUBE and was amazed to discover that in nature are to be found blocks of pyrite that grow naturally into perfect polished cubes of ironlike matter . . . The ancient Mayans and Aztecs polished such slabs of pyrite to a mirrorlike finish in a practice called scrying. Scrying was an effort to stare or gaze at an object having a shiny surface until a vision appeared, was made out dimly, or was slowly revealed. It was the earliest recorded form of divination in ancient societies of China, Egypt, and Greece.

(MODERN) SPACE

Conversely, in thinking about SPACE AS THINNED-OUT FORM, I had the idea to take the pyrite cubic mass, also known as fool's gold, and literally thin it out into space. Thus the box's interior becomes a thinning out of MASS into water-thin sheets of gold that create SPACE as a timeless, reflective dimension made even more interconnected by the introduction of burning ancient frankincense into smoke, symbolizing a further thinning out of solid form into ethereal space. . . . the aromatic resin from the Boswellia sacra tree, linked to gold, divinity and prayer, and the Three Wise

SHRINE TO THE SHIMMERING INVERSIONS OF FORM AND SPACE
5 x 5 cm pyrite cube, 3.5 x 4 cm pyrite cube, 1.25 x 1.5 x 1.25 cm pyrite cube, wood base with gold leaf application, black iron incense vase, black iron incense vase removable top, black iron "bull," Omani frankincense drops in red pouch, one brass hook, two removable brass screws.

MARWAN AL SAYED

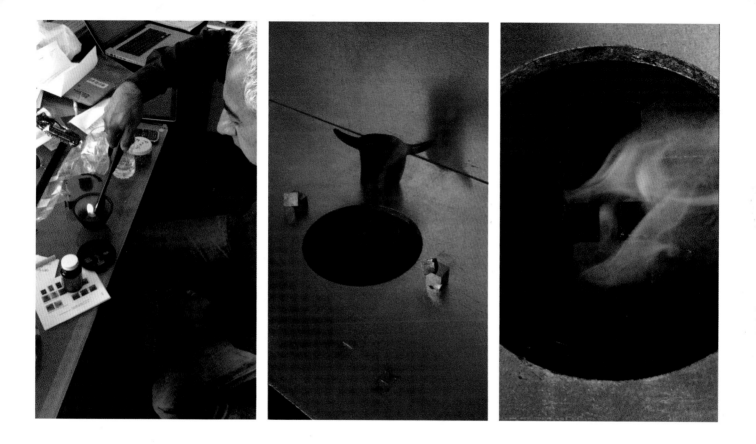

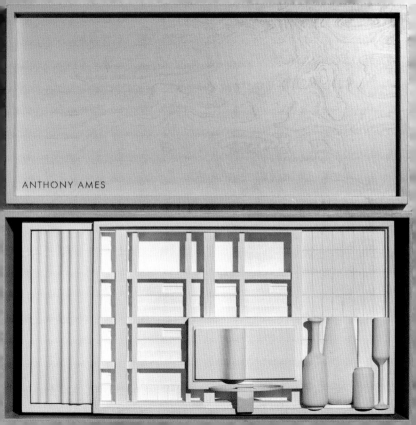

Anthony Ames

Atlanta

The composition suggests a laboratory (or playground) for architectural investigation. An illusion of depth is constructed by employing overlap, convergence, and diminution; however, through juxtaposition, superimposition, and ambiguity of scale, the perspectival effect is subverted. A dialogue is created between deep and shallow space, inviting speculation and encouraging multiple readings.

The appropriated purest object types (vases, flute, book, etc.), the view through the ribbon window framing the Terragni facade beyond, and the superimposed basketball backboard with hoop adjacent to the undulating curtain all conform to rules of an architectural discipline. They are rationally composed and organized by a system of regulating lines that defines and relocates center, defines edge and periphery, and acknowledges horizon.

Likewise, the size and shape of the components of the composition and their relationship to one another are regulated by the golden section, the square and the double square resulting in an image that is governed, controlled, and composed in its overall disposition as well as in its localized adjacencies. This ordered arrangement is simultaneously impaired by conflicting consistencies and rational irregularities. The medium is pure, ordered, and precise; however, the reading is ambiguous, speculative, and provocative. An authenticity is assured—not present in the technologically produced multiple—by placing the value of craft above the utility of expedience.

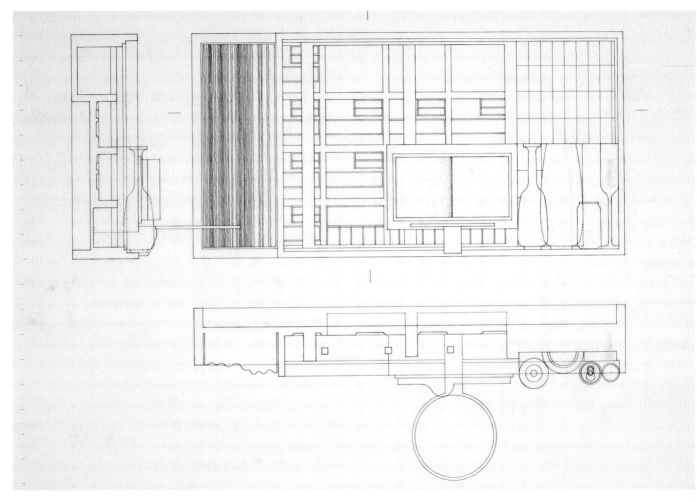

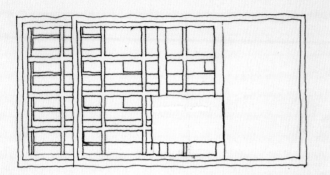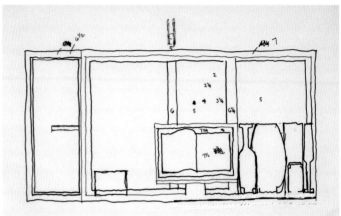

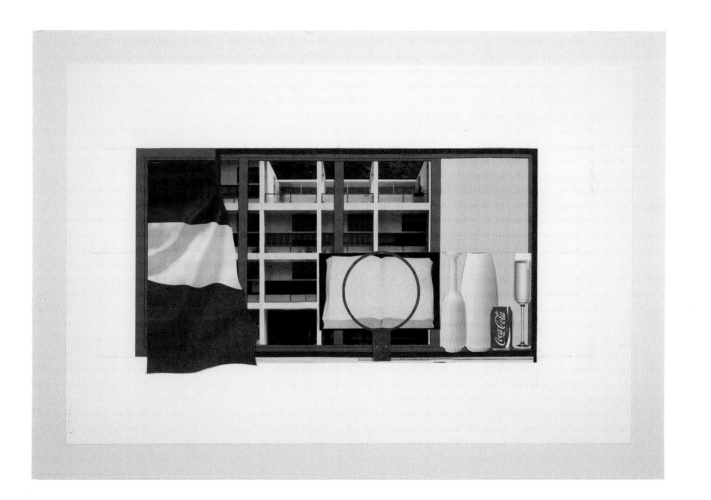

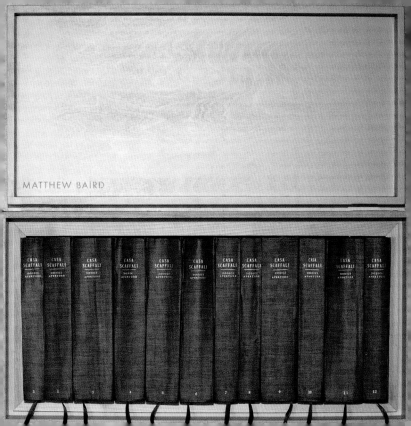

Matthew Baird

New York City

Twelve handmade books containing original drawings, recycled paper, and embedded artifacts, including drafting triangle, claro walnut wood block, tombasil white bronze sample, steel bolt and nut, goose egg shell, leather link, section of metal propeller, cast candleholder, concrete core cylinder, glass sponge, rusty nail spike, cast resin jack.

The twelve objects displayed in this box are a daily presence in my life, either sitting on my desk or lying around the studio. A few are relics of my past, while others are actual artifacts salvaged from project sites. Still others are representative of the materials that inspire and color my work. Each has nurtured my imagination and influenced my creative process. The act of selecting objects for the Biennale installation has reinforced the presence of these objects, which in many cases have become such a part of my every day that they have faded into the background.

These objects were situated into carved voids hollowed from the pages of hand-bound books, each assembled from collected drawings, sketches, documents, correspondence, and all sorts of work on paper foraged from the office recycling and storage bins. This paper, full of mundane facts and inspired ideas, is the studio's common ground. The objects are thus housed in the detritus of the work they inspired. Taken together, they are windows into the everyday life of the studio at work.

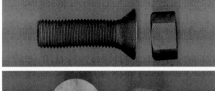

BOLT AND SCREW

CANDLE HOLDER

CONCRETE CORE DRILL

EGG

JACKS

GLASS SPONGE

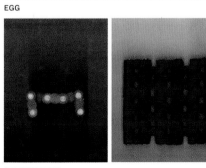

LEATHER LINK

PROPELLER

TRIANGLE

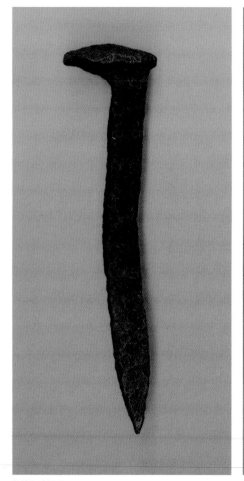

RUSTY SPIKE

WALNUT

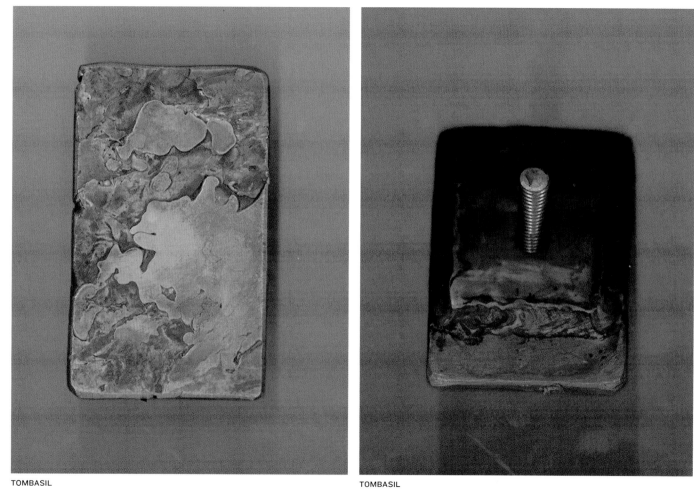

TOMBASIL

TOMBASIL

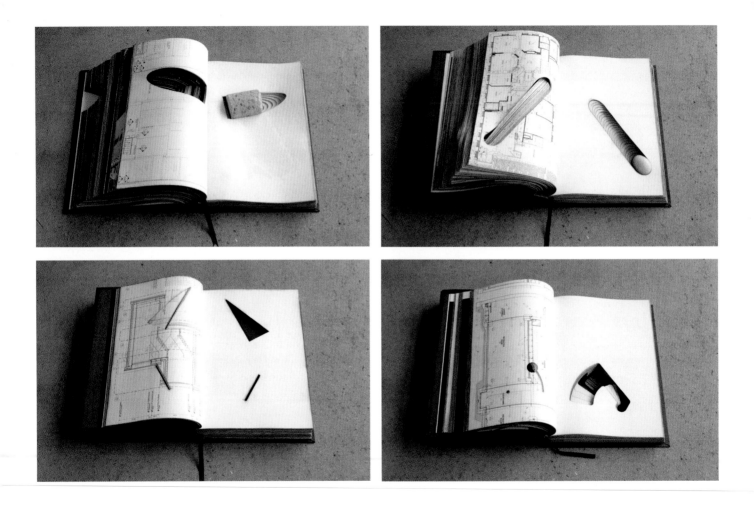

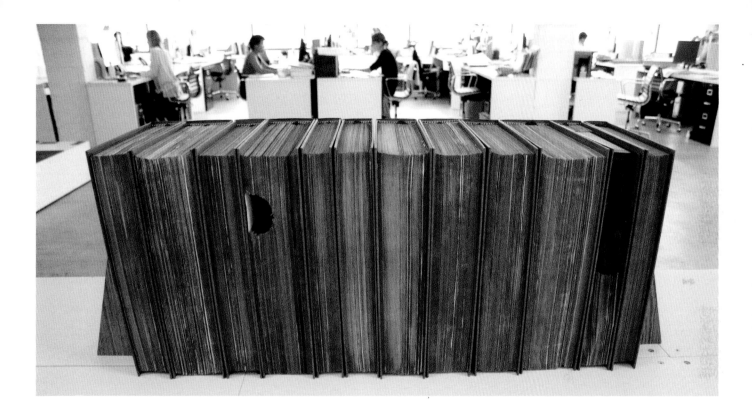

SHIGERU BAN

Shigeru Ban

Tokyo

Sketch Books

Four handmade sketch books, string.

In order to express my everyday self, I have gathered some sketches into four books. Sketches are an important part of my daily work.

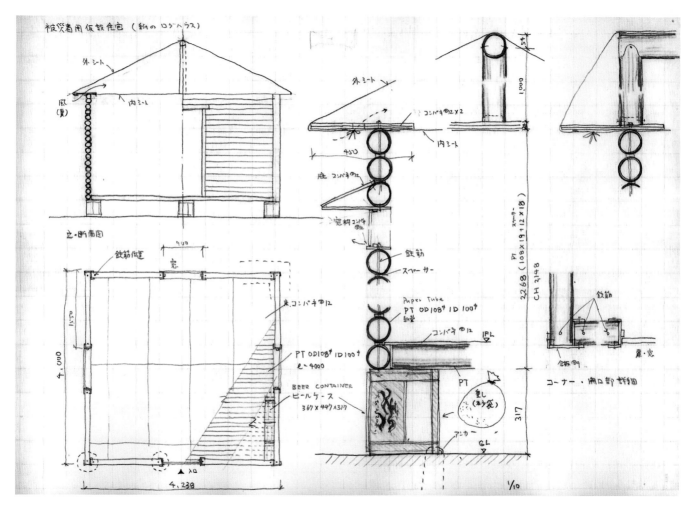

被災者用 仮設住宅 (紙の ログハウス)

外シート
内シート
凧
(質)

立·断面図

外シート
内シート

コンパネ⌀12×2

455

底 コンパネ⌀12

塗料コンテナ

鉄筋
スペーサー

Paper Tube
PT OD108φ ID100φ
紙管

コンパネ⌀12

IFL

PT

重し
(砂袋)

アンカー
GL

鉄筋位置

窓

900

床 コンパネ⌀12

PT OD108φ ID100φ
ℓ~4000

BEER CONTAINER
ビールケース
367×497×317

4,000

4,230

入口

2268 (PT 108×19+12×18) スペーサー

CH 2148

317

1000

+51

鉄筋

合板⌀12
震·窓

コーナー·開口部 詳細

1/10

53

ETFE
Foil Pillow

SEILERI LIB.

16/9/03

54

2/2

56th

14

13

12 Offices

11

10

9

8 Reception
 Museum

7 Omega

6 Luxury
 一部 Swatch

5 General

4

3

2

1

植物の壁

SPA 温泉

31F

Customer Services

Glass Shutter

Glass Shutter

Glass Shutter

55

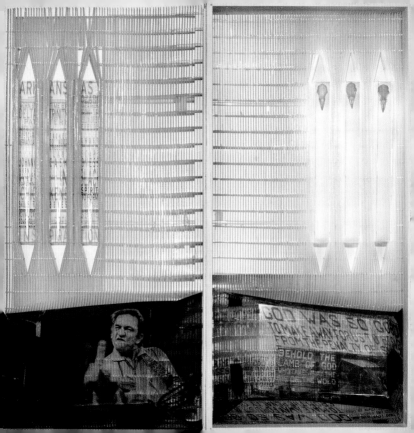

Marlon Blackwell

Fayetteville, Arkansas

INFLECTIONS OF SPIRIT OUTSIDE MY WINDOW
Plywood, steel, acrylic, vinyl, LED *strips, chicken skulls, Johnny Cash photograph (Jim Marshall Photography LLC), barn photograph (Jake Rjas).*

arkansas ozark mountains worn by time by weather tipped toward mississippi river delta

the pattern after forest the mathematics of cotton rice patchwork of landscape of rural electrification

measured pole to pole to pole wires overhead brown dirt below green fields

and american postcard vernacular occasional punctuating shots of color from placards or posters

tacked to wood creosote stained and shot full of holes woodpecker ghost risen up from this Arkansas

landscape land of the trinity johnny cash dyess born million dollar quartet when a million meant something

memphis bound and beyond in black in rows of two of three of five long house chickens feed me

give spirit to form to skulls to bones lucinda lucida lucid stories of this place from this space revival tent

ephemeral and songs acute and real picture this this pictorial ancient alligator gar land reverent

and irreverent and kin to jerry lee high low and in between the source and the inspiration

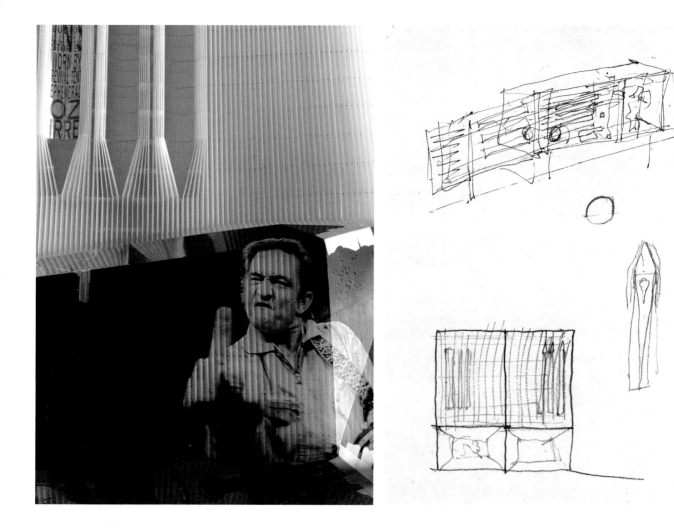

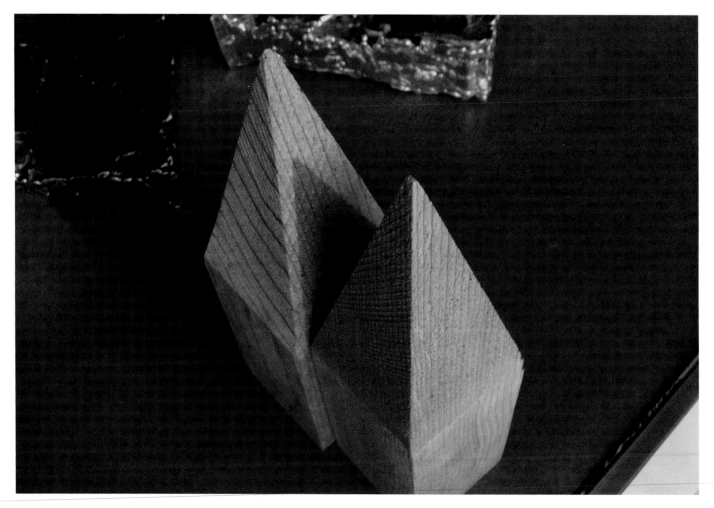

Will Bruder

Phoenix, Arizona

304 stakes PLUS . . .

A study of the potentials of modular variability . . .

My box is a vessel that celebrates my belief that in the ordinary and everyday resides the potential to create challenging inventions of mystery and beauty.

67

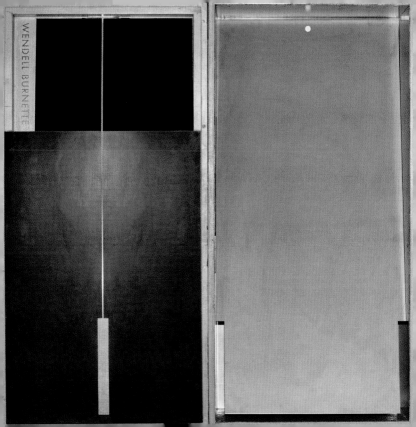

Wendell Burnette

Phoenix, Arizona

BOX OF LIGHT

10 GA mill-finish 2B stainless-steel plate, 16 GA hot-rolled mill-finish steel plate with matte wax finish, 0.063 brass plate; all "blind" assembly with 3M tape.

Idea: Our box is treated the only way we know how—first as a physical "site" and second as a "space" that can facilitate a dialogue with the context of the Casa Scaffali in a variety of ways as determined by Tod and Billie. Our initial impulse was to expand the physical dimensions of the box, the perceived limits of the box, and its eventual site condition at the Biennale. We wanted to ship the crispness of our dry desert light, our "colored air" day and night, across "the pond" and allow it to mix and mingle with the heavy aquatic light and atmosphere of Venice in some way.

Method: Sixteen-gauge hot-rolled mill-finish steel sheets line and expand the four sides of the box, their inherent material qualities amplified with a matte wax finish. This tight, seamless lining reflects the available light at any given time that is absorbed into a single sheet of 10-gauge mill-finish 2B stainless steel that bisects the longest dimension of the box while still allowing the top of the box to be attached. A three-sided, asymmetrically notched trough at one end, with our stenciled name, accommodates this shipping connection and is lined with "broken back 0.063 brass" on three sides to pump a warm glow from within when it happens to capture any stray direct light. One drilled hole at the opposite end does the same. The bottom of the box can be positioned vertically in two ways: to reflect the sky or ceiling or passersby, or, by flipping, to reflect the detail of the ground or the entire space, depending on the height of its vertical position. It can also be laid down on its side, horizontally reflecting one condition or another, or be faced upward. The top of the box, also treated as a "site," is clad edge to edge in one sheet of waxed mill-finish steel plate, slit almost all the way down the middle and "broken" at the notched trough to accept the long mill-finish stainless-steel plate during transport. The slit/slot is lined on two sides and below with a long diagonal piece of 0.063 brass that is never the same distance from the mill-finish steel plate above, so that it captures and bounces light differentially within this small fissure. All metalwork was precisely crafted and fitted up "blind" with 3M tape by my collaborators here in Phoenix at Metalworks, Inc. The two pieces of the box can be arranged together or across from each other in any configuration that maximizes the dialogue between our "place" here in the Arizona desert and the "place" that is Venice.

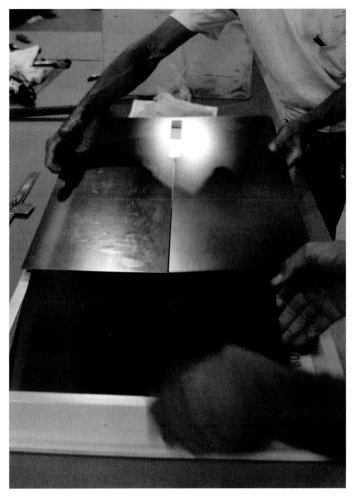

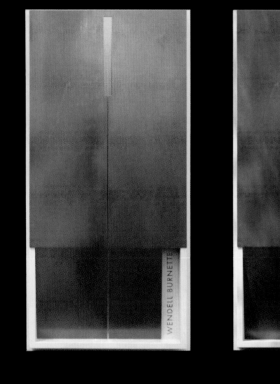
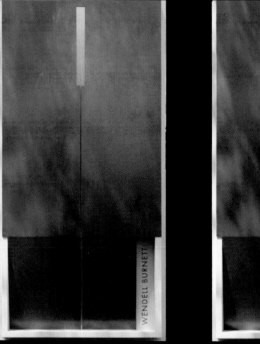

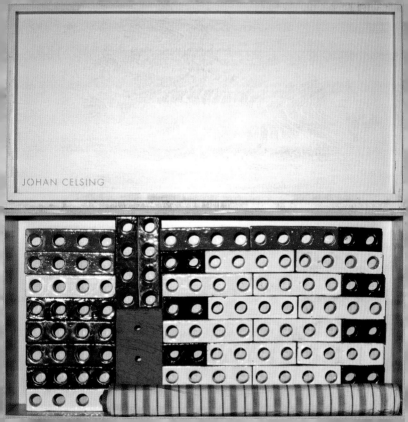

Johan Celsing

Stockholm

Bricks, Fabric

Forty-three perforated glazed bricks (twenty-two white, nine brown, five red, five yellow, two green), one perforated unglazed red brick, one piece green, white, and red silk fabric.

I have found brick a very interesting material ever since childhood. The elementary qualities, as well as the rich possibilities of treatment, even with limited tools, is inspiring. The rules and limitations of traditional masonry have the exciting paradox of opening to seemingly endless possibilities of patterns and other subtle variations (treatment of mortar, joints, etc.). The atmospheric qualities are one side of this great material, as is its impressive weight—not to speak of durability. Glazed bricks or tiles that are used in the Middle East combine weight and delicacy in a particular way.

Recently we have used colored glazed bricks (standard bricks glazed on one or two sides) in several built projects with massive load-bearing walls. For the Church at Årsta in Stockholm we needed masonry walls with sound-absorbing properties. Luckily, we found Danish standard bricks with circular perforations, which we glazed in different colors for use in the sacristy and in an adjacent chapel. Currently under construction is a 25-meter-long wall, entirely clad with perforated white bricks, in the furnace hall of the new crematorium at the Woodland Cemetery in Stockholm. There the brilliance of the glazing, combined with skylights overhead, transforms the wall to reflect the light.

Since studying architecture I have now and then bought fabrics that I find interesting. Over the years we have affixed a variety of these textiles to the available surfaces in our home. I am fascinated by the pieces in many ways. There are direct atmospheric qualities, obvious at first glance, but there are also intricate patterns in the weaving of which you might not be aware at first. Many of them seem elementary but are refined and complicated.

It is remarkable that the intricate patterns are sometimes surprisingly similar despite coming from very different places. The textiles are varied: some are ordinary commercial products in one color with an intriguing pattern; some more colorful ones were brought home from visits to the Middle East or the Andes in Peru; some are traditional Swedish fabrics with a surprisingly exotic appearance. The floors of our office are covered with inexpensive so-called trash carpets of reused cotton that are common in Sweden. The fabric for the exhibition is a tightly woven silk fabric found twenty-five years ago in a tiny old workshop in a Mallorcan village.

As different as they are, bricks and textiles have a strong link, and of course the use of delicate woven tapestries in ancient times meant that even crude structures and interiors could be adorned for ceremonial festivities. On the other hand, the visual qualities of textiles are strikingly apparent on many brick buildings. As we know, Louis Sullivan commented on this, and such facts are the well-known basis for the fascinating theories of Gottfried Semper, the Bekleidungstheorie and the Stoffwechseltheorie.

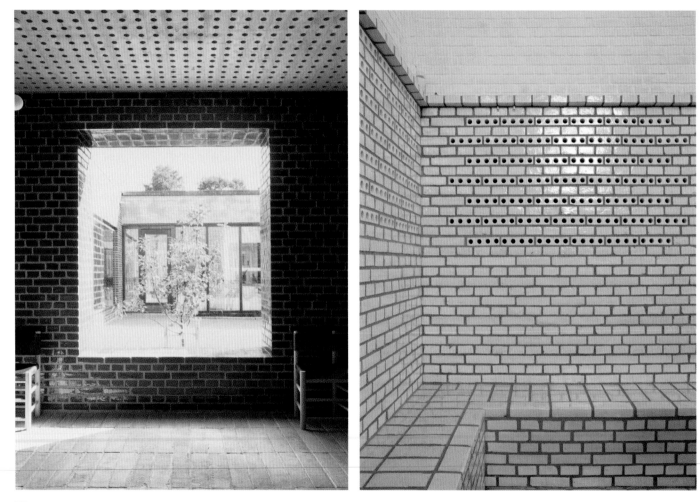

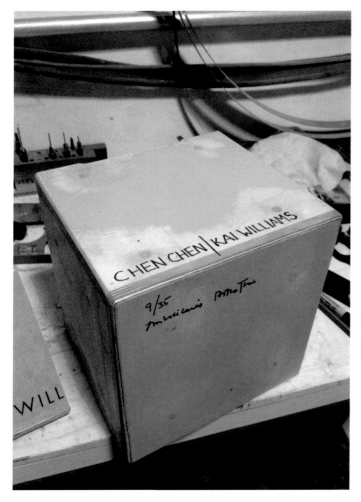

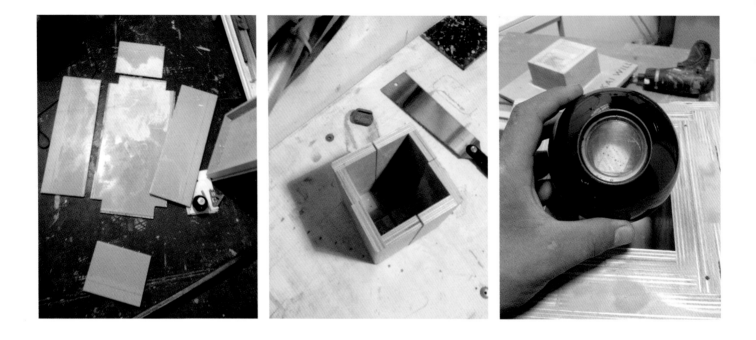

Chen Chen & Kai Williams

Brooklyn, New York

Plywood, plastic magic eight ball, brackish water.

After initial test explorations we deconstructed the provided box and remade it into a smaller, thicker box, using all the wood from the previous box. The new box was sized to closely fit one magic eight ball. The eight ball was drained of ink for transport and refilled with the brackish water of Venice's lagoon.

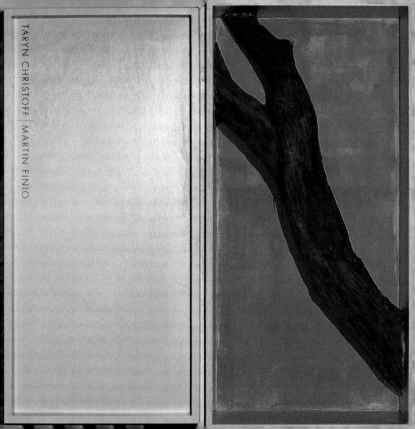

TARYN CHRISTOFF | MARTIN FINIO

Taryn Christoff & Martin Finio

New York City

Boxed Woods

Mountain laurel branch, paint, unidentified insects from said branch.

What we realized when faced with the terrifying prospect of filling an empty box with something meaningful is that, as architects, we are editors before we are collectors. We do not overly fetishize objects, and neither do we own many things.

What moves us more are the operations and processes that create objects, rather than the objects themselves. We were much more interested in performing something *on* the box than we were in putting something *in* the box. Or at least one of us was. The other felt very strongly that something organic, natural, and raw go inside, something that would play off the box's measured and manufactured precision. After much debate we agreed on a tree limb, as it represents the material origins of the box itself, has its own structural logic and pattern of growth, and is the perfect sinuous foil to the box's calibrated frame.

To satisfy the other's interest (that is, the one looking to undermine the *boxness* of the box), the limb and box were made to be inextricably linked. The box doesn't so much contain the limb as engage with it in a way that reveals something distinct about the nature of each object. The organic and the artificial are seamlessly intertwined, which is how we see our work, and the decisionmaking process that went into it reflects the productively conflicting (yet always ultimately synchronizing) way that we work together.

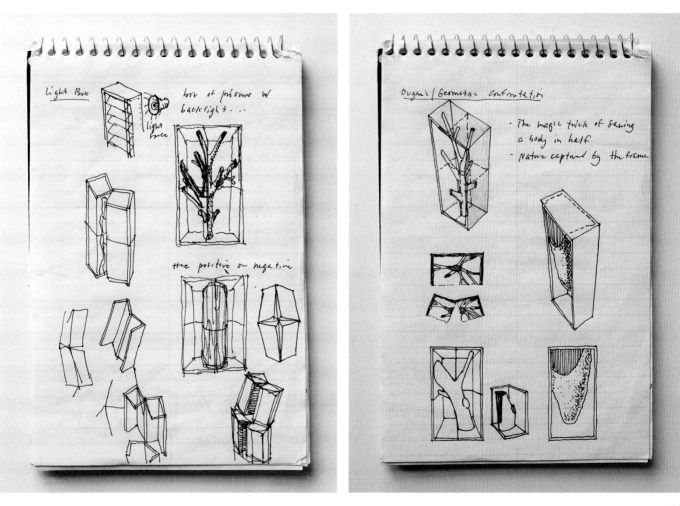

Light Box

box of prisms w/ backlight...

light source

tree positive or negative

Organic/Geometric confrontation

- The magic trick of sawing a body in half
- Nature captured by the frame

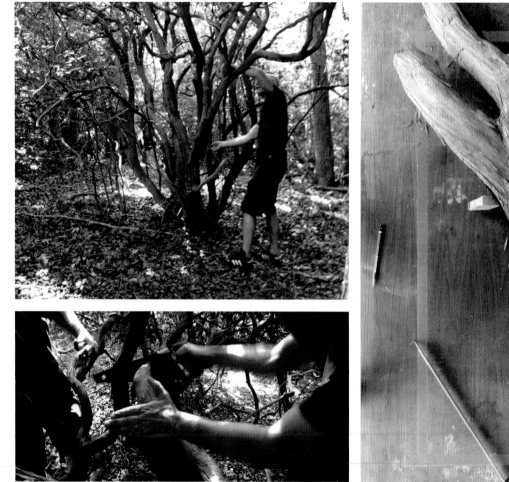
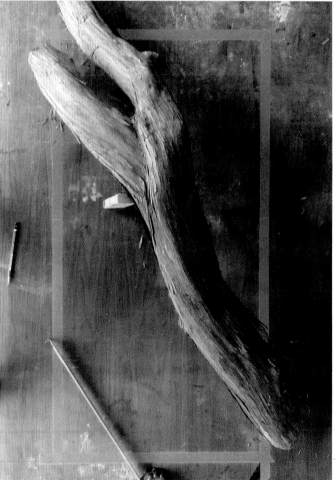

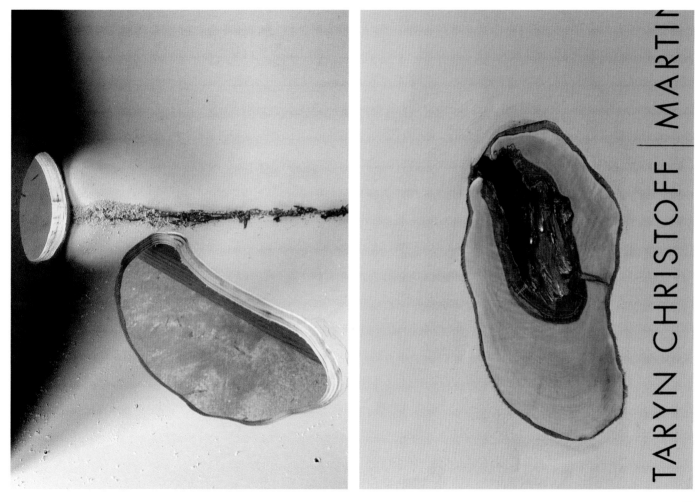

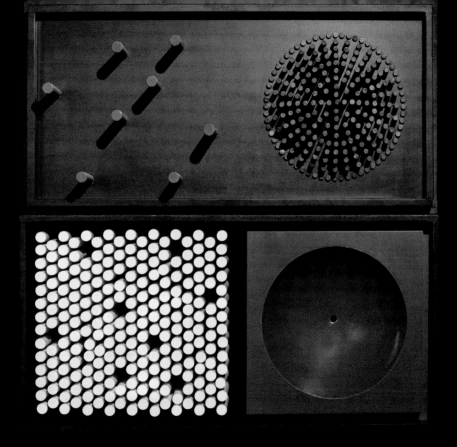

Annie Chu & Rick Gooding

Los Angeles

DYAD BOX—ABOUT 2S

Painted wood, lacquered MDF.

Is the box just a container, or is the box defined by what it contains? A small child, an engagement ring, a gift, forensic evidence, a corpse, a lost pup, things that can save a life, things that will kill you . . . they all live in a box for a while.

The box and lid are a set of conundrums: while the box bears the secret, the lid is the guardian. A box without a lid is still a box, a lid without a box is questioned about its lost partner, and quickly appropriated as a sort of box when turned upside down.

What about the anticipation, the performance of unpacking, the satisfaction of closing the box knowing that its contents are secure for the moment, or that the box will be buried and the secret of its contents lost?

We were first drawn to the dynamic act of unpacking a nested set of forms, and the idea of a narrative of colors that can unfold with each successive layer revealed. Can the repetitive act be the métier for the box, referring to its identity over again?

As it often does, that first idea will be a trace of what we initially intended for it.

As it often does, our conversation shifted: two people who share many common references but are coming at the question from very different biases. Inevitably one idea is too contrived, one lacks clarity, one lacks interest in the viewer/reader, one is too obscure, one is incapable of shouldering more meaning . . . until we recalled a shared experience that impressed us with the question at hand: Lucas Samaras's *Stiff Box #10* from a visit to the Modern Art Museum in Fort Worth. *Stiff Box #10* posed tantalizing questions of the relationship between the container and the contained. It was a dyad—a two—a divided container where the two sides effected the same question, and the divided lid reiterated it. It was a rich orchestration of refrain and resonance; all in a dense mass of fine orange rusted steel.

Could we capture some of the power of that ricochet? With the most Italian of color schemes?

For the black painted interior of the box:
a glossy green bowl with a hole (intensifying longing to be filled), the other an incomplete grid of matte white dowels (a humming longing for reunion with its missing members).

For the black painted interior of the lid:
a hemisphere of matte black dowels (a hedgehog) to fulfill the glossy green bowl and the hole, and a few black glossy dowels to rejoin the incomplete grid.

Just a primary set of questions for the fluctuating identity of what is the container and what is contained.

Analogous questions can be posed for interior architecture, the lens we see through the most . . . with lots of potency waiting to be mined.

TO HINGE OR NOT TO HINGE

NESTING

HINGE

±30"

HINGE

HINGE TO WORK ON EDGE

½" LID

ALLOW FOR LID TO CLOSE

DOWEL

POS MED

POS MED

LID BASE

PROP UP

CORTEN STEEL

LUCAS SAMARAS
STIFF BOX #10
FT. WORTH
MUSEUM OF ART
(ANDO BLDG)

MALE

SEPTUM

FEMALE

BED OF NAILS

FINGERS
STITCH
ZIPPER

BOWL

DOWEL

PIPE

LID

CENTERPOINT OF
BOWL RELATIVE TO
BOX
CAN YASHI MAKE THIS?

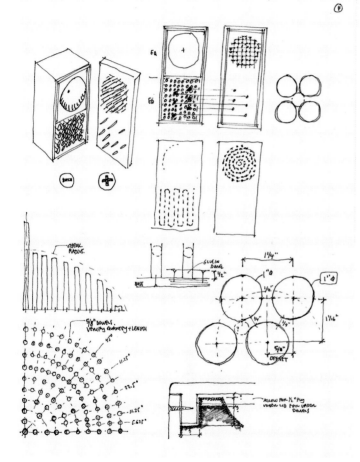

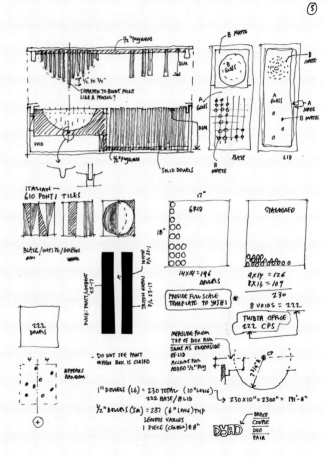

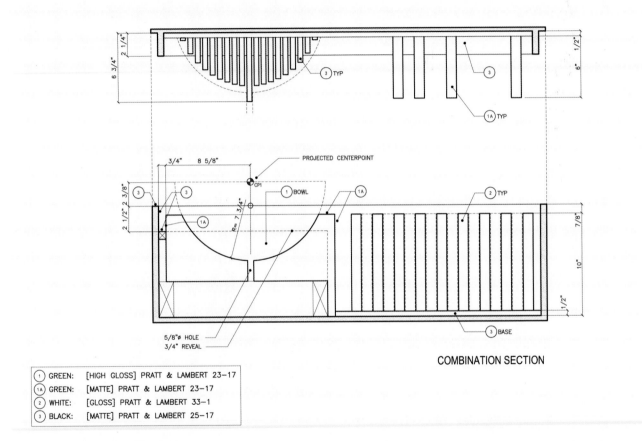

COMBINATION SECTION

2 1/4"
6 3/4"
1/2"
6"

PROJECTED CENTERPOINT

CP1

3/4" 8 5/8"

2 3/8"

2 1/2"

R = 7 3/4"

1 BOWL

1A

2 TYP

7/8"

10"

1/2"

5/8"Ø HOLE

3/4" REVEAL

3 BASE

3 TYP

1A TYP

① GREEN: [HIGH GLOSS] PRATT & LAMBERT 23—17
①A GREEN: [MATTE] PRATT & LAMBERT 23—17
② WHITE: [GLOSS] PRATT & LAMBERT 33—1
③ BLACK: [MATTE] PRATT & LAMBERT 25—17

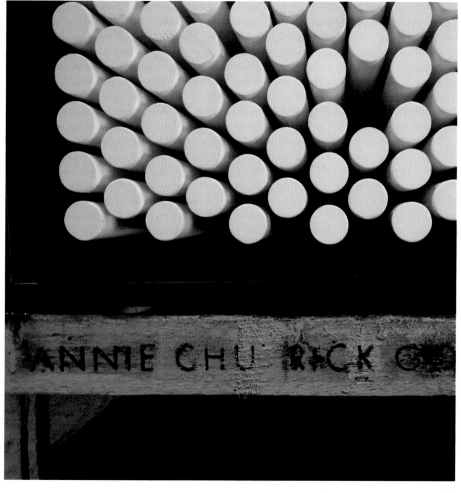

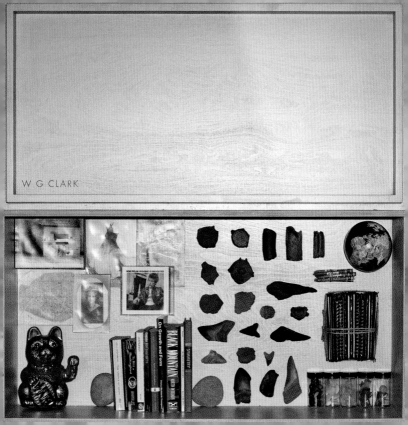

WG Clark

Charlottesville, Virginia

Twenty used appointment books tied up with string, nine assorted wax crayons, one Earth globe, eight fossilized shark teeth, one fossilized equus tooth, six fossilized vertebrae, one fossilized clam, six fossilized bones, two Native American pottery shards, five vials containing fossils, pebbles, and sea glass, two stones, one Maneki-neko waving cat, Bob Dylan's HIGHWAY 61 REVISITED *CD, battery-operated digital recorder. Sixteen images: Byrd Mill, Louisa, Virginia; teepee; Pueblo Bonito; Iroquois longhouse; Mesa de Verde Anasazi pueblo; map of Paris; Serpent Mound; seven rural South Carolina shacks; Sheldon Church ruins, Yemassee, South Carolina; Reese Thomas Clark. Nine books:* NOTES ON THE STATE OF VIRGINIA, *Thomas Jefferson;* GRAPES OF WRATH, *John Steinbeck;* TO KILL A MOCKINGBIRD, *Harper Lee;* WALDEN/CIVIL DISOBEDIENCE, *Henry David Thoreau;* SELF-RELIANCE AND OTHER ESSAYS, *Ralph Waldo Emerson;* NAUSEA, *Jean-Paul Sartre;* BLACK MOUNTAIN: AN EXPLORATION IN COMMUNITY, *Martin Duberman;* SYMMETRY, *Herman Weyl;* ON GROWTH AND FORM, *Darcy Wentworth Thompson.*

This box doesn't contain references to architecture so much as it contains references to the Earth.

Much of the collection comprises fossils collected by me in South Carolina along with found Native American pottery shards, five vials containing pebbles, more small fossils, sea glass.

A globe of the Earth is included, as are twenty calendar notebooks representing twenty years of teaching architecture. Crayons represent a love of drawing from an early age. The books largely represent ethical positions that I've admired. Bob Dylan is included because of his influence on our lives; *Highway 61 Revisited* is when everything changed, including me.

Mounted images include my grandmother and places that have been very important. The digital recorder plays a continuous loop of a mockingbird song whose intrepid inventiveness never ceases to amaze me. It's poignant and always new each time you hear it.

And then there's the waving cat . . .

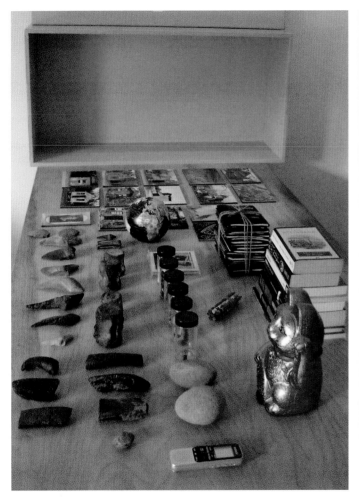

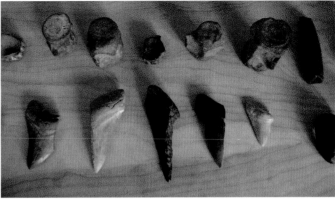

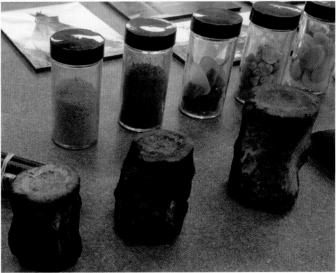

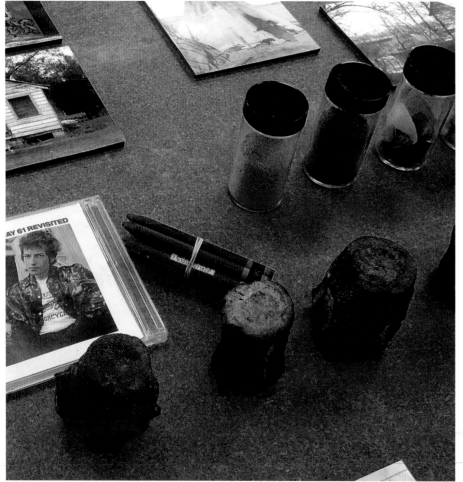

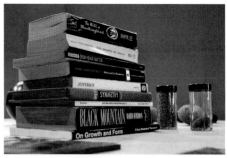

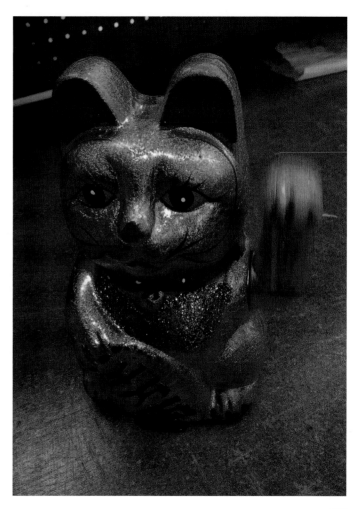

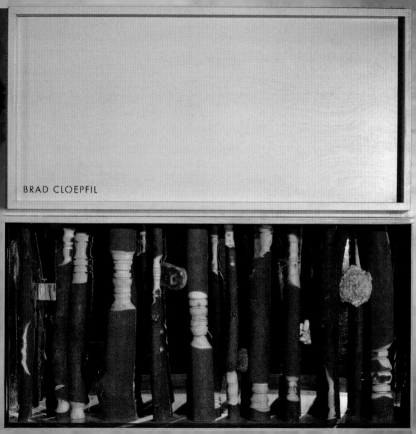

BRAD CLOEPFIL

Brad Cloepfil

Portland, Oregon

STICKS AND STONES

Acrylic mirror, twenty-four Oregon laurelwood sticks turned on a lathe, Oregon rocks and minerals, including snakeskin agate, thundereggs, petrified wood, obsidian.

Our home is in Oregon, the Pacific Northwest. It is a place formed by violent forces that have over time yielded a landscape of tremendous power, vitality, and beauty. The raw materials that are abundant here—timber, stone, obsidian—are records of change. Like the landscapes they define, each material is a site, a locus of potential.

Our inspiration for this project is rooted in the land, the innate qualities of material, and, equally, in the possibilities of making, memory, and infinite space.

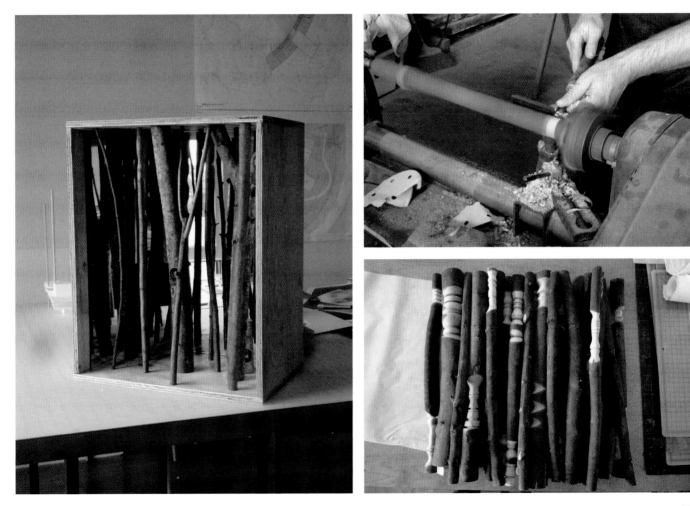

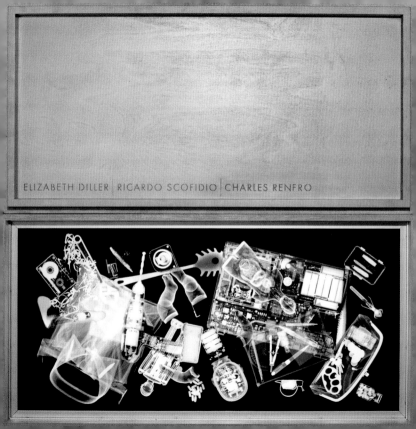

ELIZABETH DILLER | RICARDO SCOFIDIO | CHARLES RENFRO

Elizabeth Diller, Ricardo Scofidio & Charles Renfro

New York City

DNA Project

Light Box: x-rays, LEDs.

Tod and Billie's invitation to contribute to their Venice Biennale project resulted in an X-ray image of some items briefly placed within the box they sent us. Some of the objects had an actual history in former projects, and some had only been pareidolia for our minds. Scattered within were a few pieces of leftover pentimenti that produced investigations into something else. A few have meaning only for us.

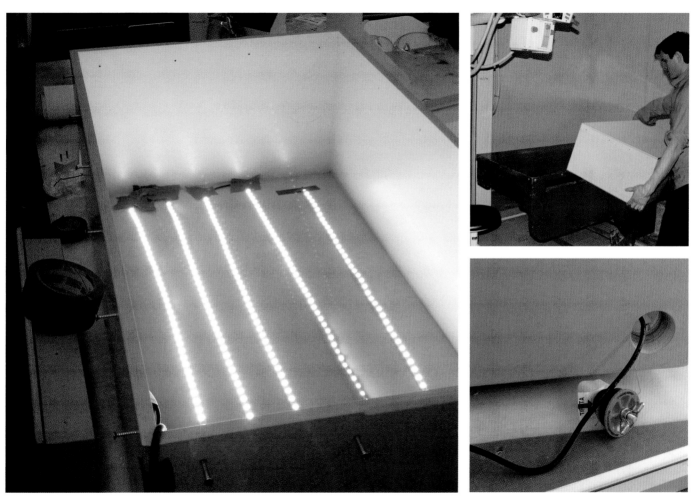

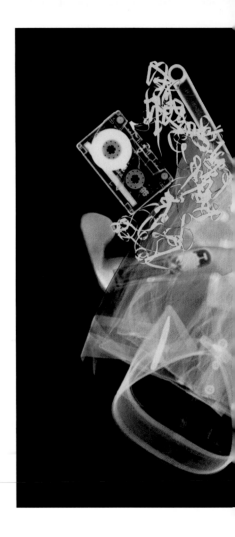

PETER EISENMAN

Peter Eisenman

New York City

There are two basic architectural planning strategies: a four-square and a nine-square grid. Our project, *My Memory*, is the spatial intersection of a three-dimensional nine-square grid with a four-square grid. Initially they were the same scale, but in order for them to intersect spatially the four-square grid was enlarged slightly. Inherently different, the nine-square is stabilized by its central volume while the four-square is unstable, centered on a point of intersection. By engaging with the corner of a frame (the box) the grids create a spatial tension that provokes an examination of the fundamental difference between these two geometric strategies. One important note about the site (the box): the work is incomplete when the box is open; the remainder of the two grids is attached to the lid. When the box is closed and the work is completed it cannot be photographed — *My Memory*.

The grids were destroyed in transit to Venice; the surviving fragment, a piece of the four-square that penetrated the plane of the box, is the only remaining mark of the project, hence the title *My Memory*. Another memory is the lone four-square column at the far corner of the box, which is a reminder of the Bramante's corner at the Cortile at Santa Maria della Pace in Rome.

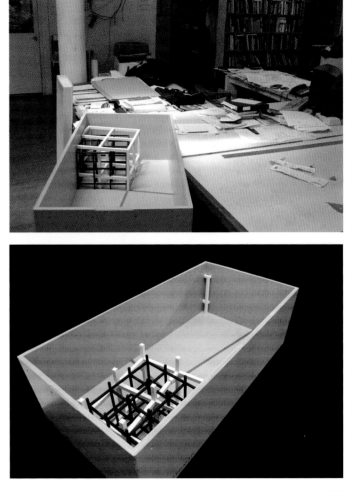

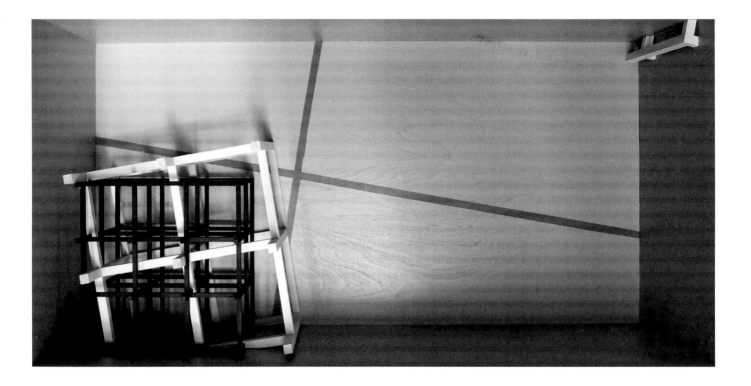

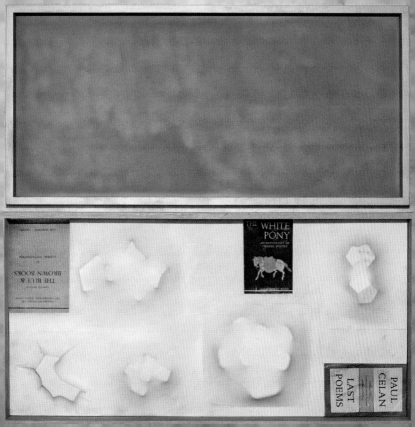

THE WHITE
PONY

AN ANTHOLOGY OF CHINESE POETRY

THE BLUE & BROWN BOOKS

PAUL CELAN

LAST POEMS

Steven Holl

New York City

Words|Space

One vacuum-formed sculpture and three books: THE WHITE PONY, *edited by Robert Payne;* LAST POEMS, *Paul Celan;* THE BLUE AND BROWN BOOKS, *Ludwig Wittgenstein.*

The vacuum-formed geometries push up from a foundation of words that are meant to represent the core effort toward "poetic knowledge" that is found between structure and idea.

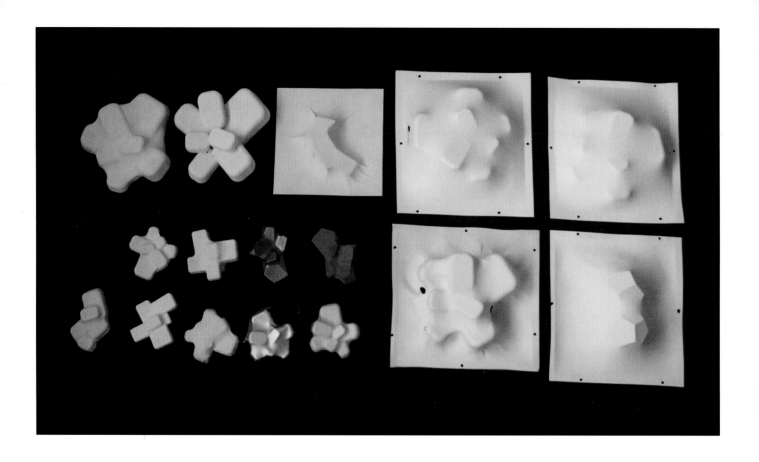

6/18/10 Scholl

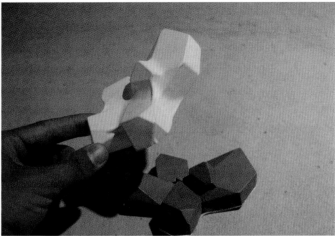

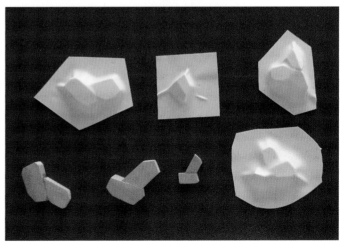

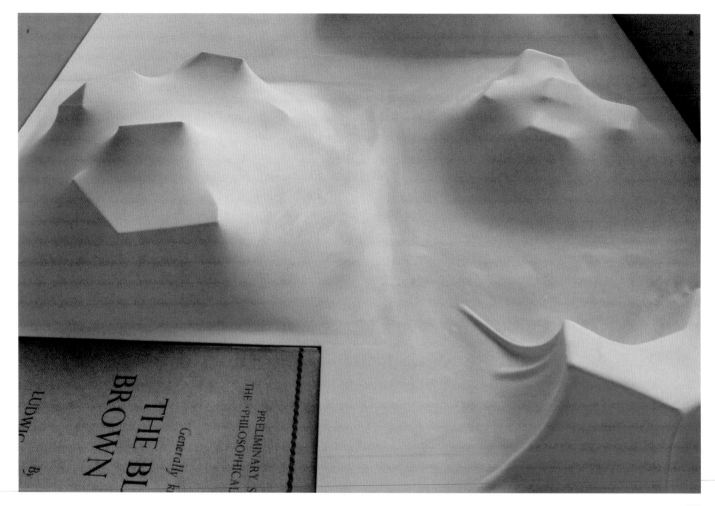

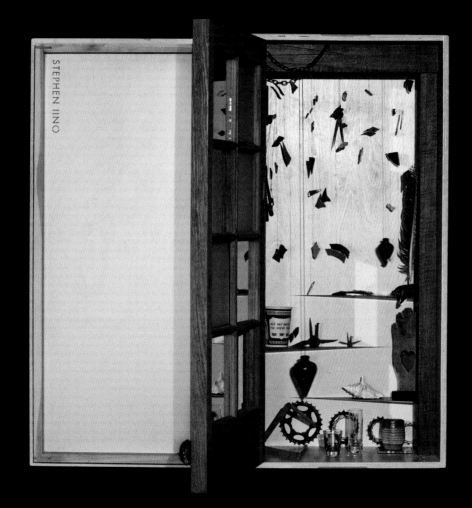

Stephen Iino

Paterson, New Jersey

DISTRACTED

One fir plywood ceiling hanging panel with light blue stain, red oak door with mirror and frosted glass panes, two steel butt hinges, steel doorknob, claro walnut screen frame, aluminum screen, two hardwood coasters, one WNYC shot glass, one "I Love NY" shot glass, one "We Are Happy to Serve You" coffee cup, one ceramic teacup, one piece of blackened and waxed steel chain with two steel screw eyes, one oak and cherrywood TM/SI heart-in-hand sculpture, two origami cranes, one steel wrench for chime with claro walnut hanging plate, one steel ball chime strike suspended on nylon squid line, one claro walnut chime strike pusher, several dozen pieces of broken mirror on Kevlar thread, fir plywood driftwood piece (approx. $1/4 \times 2\,1/2 \times 7$ in.), one wood and brass folding ruler, four steel bicycle sprockets, miscellaneous nails and screws, two glass beads, three claro walnut knife-edge shelves with epoxy finish, one small conch shell, one falcon feather in driftwood stand.

Over the years I have accumulated many objects. From pieces of trash to items made by myself and others; from things that I like to those I think can be fixed, reused, or repurposed; things which evoke memories. When I make something for a client, I have a hard time throwing away the remaining material cutoffs, scraps, jigs, and templates after the job is completed. Oddly, though, when Billie and Tod asked me to put things in this box, nothing jumped out as something that must be included.

Instead, what I wanted to put in were the engagements that I have with people, materials and physical constants, and the act of making itself.

What I've chosen to include represent these engagements as well as symbolize my own personal attributes that contributed to shaping those relationships and the process.

Some important things that are impossible to experience from looking at photographs of this piece:

1) The weight of the door as you open and close it and the resistance of the door catch.
2) The bright ring of the wrench chime being struck by a steel ball raised by the action of opening and closing the door.
3) The movement of the objects suspended in the box and that of the light reflecting off those objects.

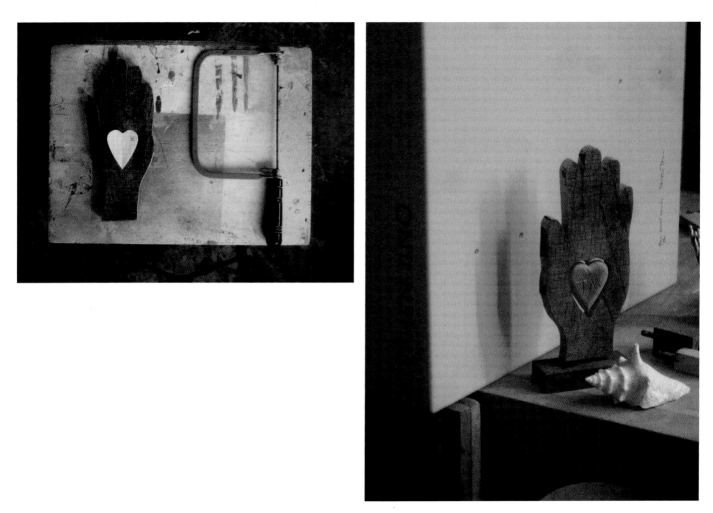

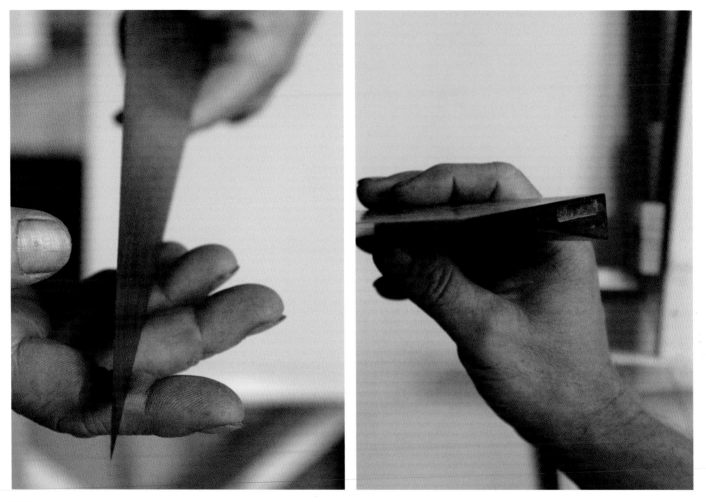

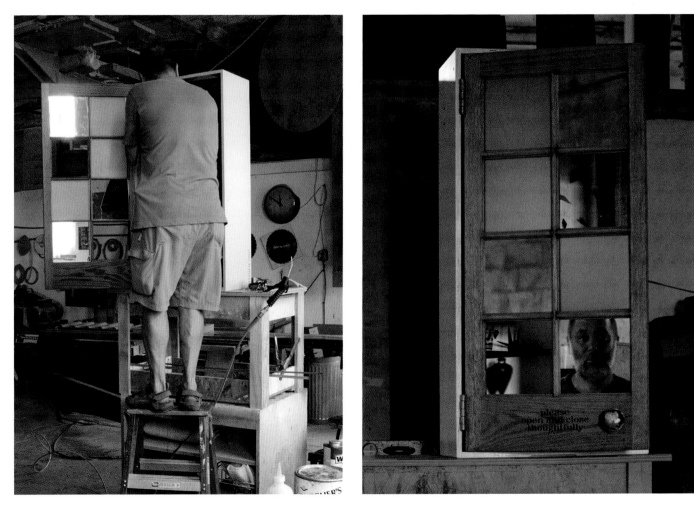

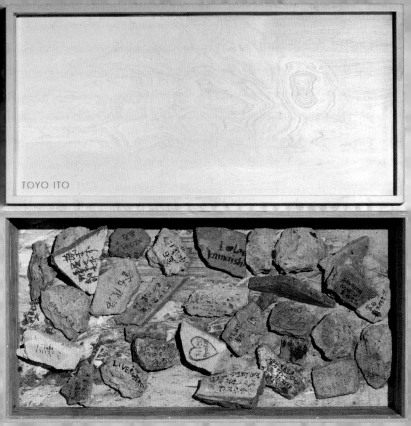

TOYO ITO

Toyo Ito

Tokyo

RISING FROM A LOST VILLAGE

Interior of box lined with photograph, thirty-three pieces of rubble (stone and concrete), approx. 15 × 11 × 5 cm each.

The seashore village of Sanriku in northeastern Japan lost everything in an instant due to the severe earthquake and tsunami of March 11, 2011. What was left behind was a huge amount of rubble. Things inscribed with the memories of the people who had lived there—a clock that stopped at the time the earthquake struck, family albums, children's toys—were mercilessly brought to light.

The debris was gradually removed and the memories grew less painful, but many places remain empty and unorganized. Memories of the past are retained by the frames of roofless buildings. Traces of torn-down houses appear like floor plans drawn with concrete. Around the frame-only buildings the weeds are growing wildly, and seagulls that had disappeared after the tsunami are back again, flying around the seashore.

Should we attribute all of this to the laws of nature? The people who left this place will likely also come back to lead their lives again. Even if they are advised to move to higher ground, considering the potential of another tsunami, people like to return to where they had lived, just as animals and plants do—whether by following animal instinct or the laws of nature.

A new village cannot help being launched on this frame inheriting the memories that remain. Like grasses and trees that grow in ruins, a new, stronger village will stand high upon the foundations formed in the past, dreaming of a bright future.

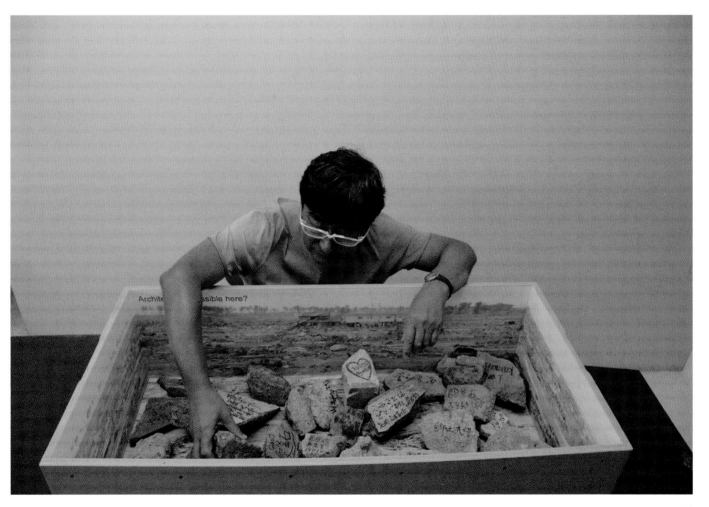

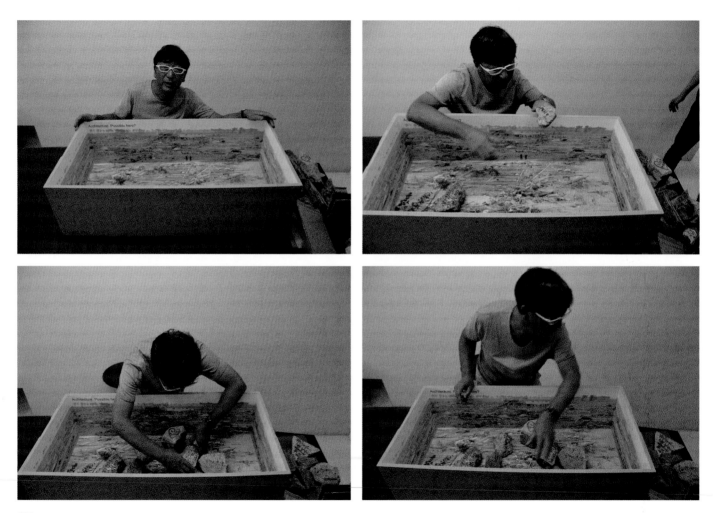

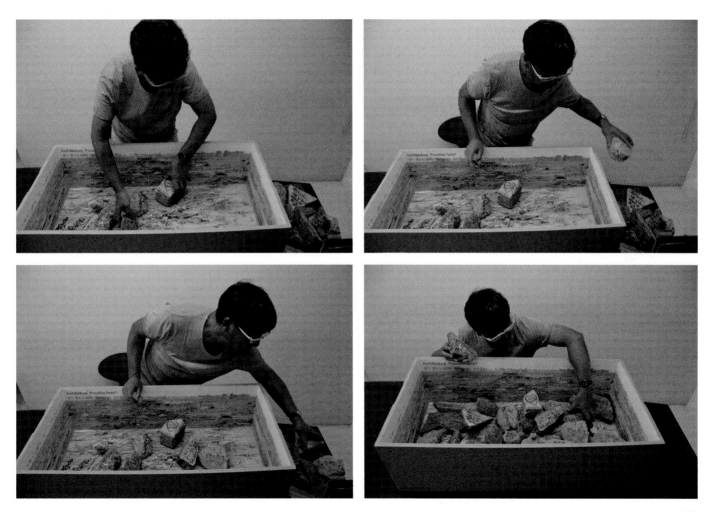

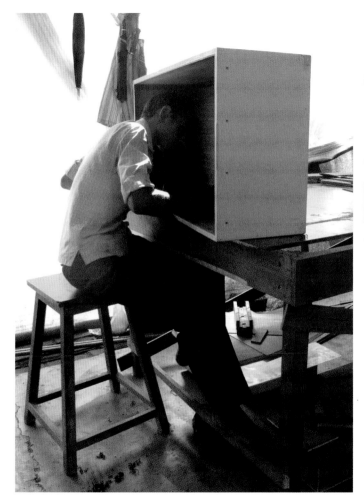

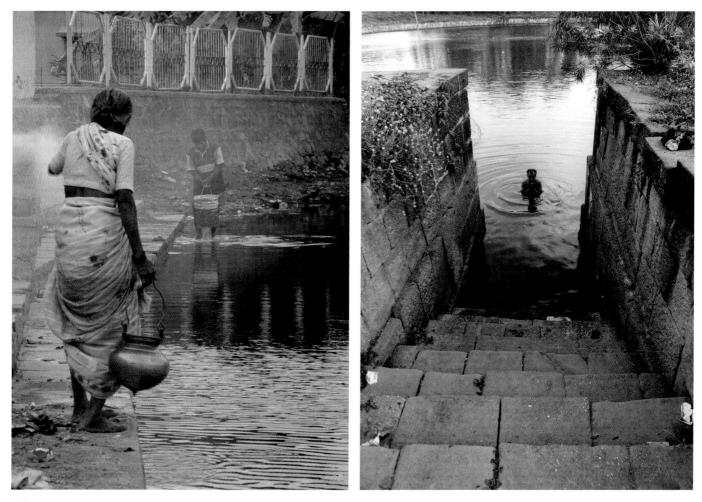

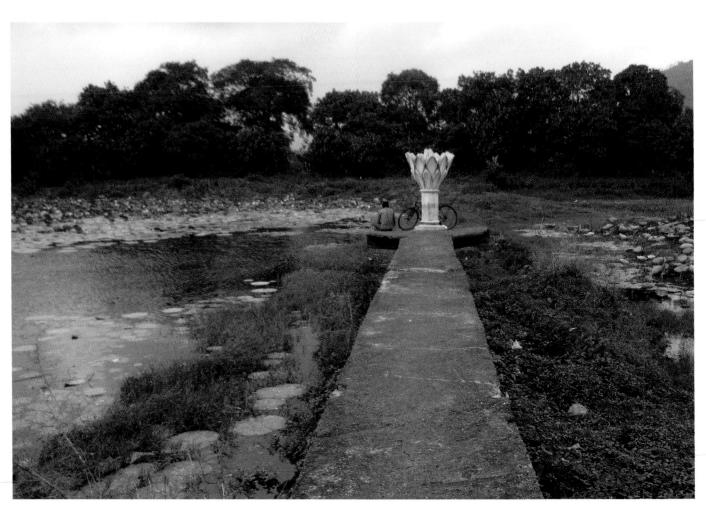

Bijoy Jain

Mumbai

Mixed media, including wood paneling, photographs, eleven brass models, three headphones, one digital photo frame.

"To the Great King . . . there occurred the thought:
'Suppose, now, I were to make Lotus-ponds in the spaces between these palms . . .
With four flights of steps, of four different kinds.
One flight of steps was gold, and one of silver, and one of beryl, and one of crystal . . .
Suppose, now, I were to have flowers of every season planted in those Lotus-ponds . . .
Suppose, now, I were to place bathing-men on the banks of those Lotus-ponds,
To bathe such of the people as come here from time to time.'"

—Ancient Buddhist Sutra

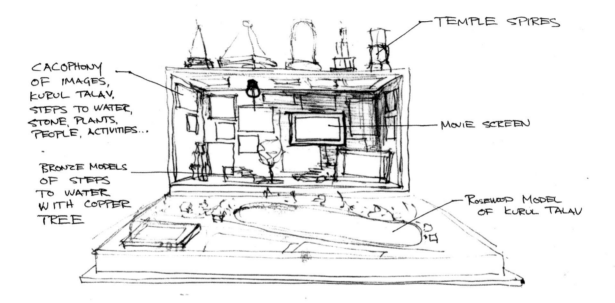

TEMPLE SPIRES

CACOPHONY
OF IMAGES,
KURUL TALAV,
STEPS TO WATER,
STONE, PLANTS,
PEOPLE, ACTIVITIES...

MOVIE SCREEN

BRONZE MODELS
OF STEPS
TO WATER
WITH COPPER
TREE

ROSEWOOD MODEL
OF KURUL TALAV

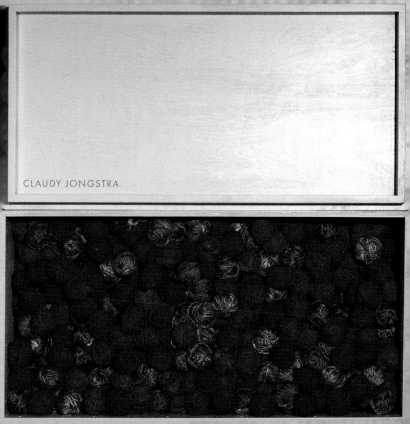

CLAUDY JONGSTRA

Claudy Jongstra

Friesland, Netherlands

Ten thousand meters of wool and silk dyed with thirty kilos of onion, carded, and hand-spun into six hundred golden balls.

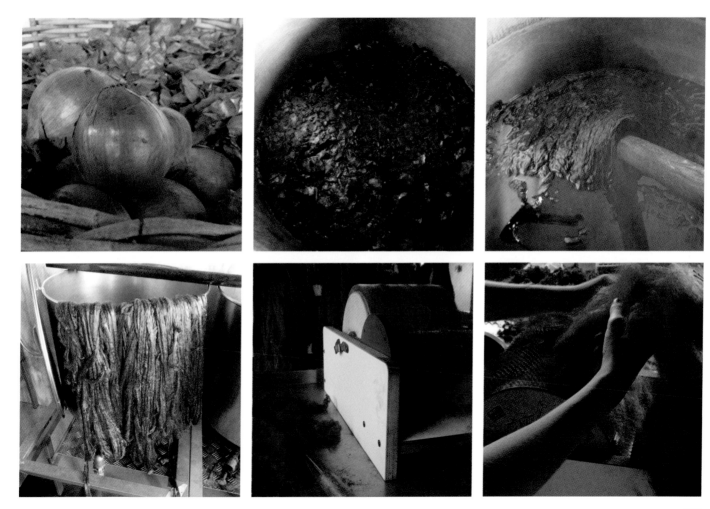

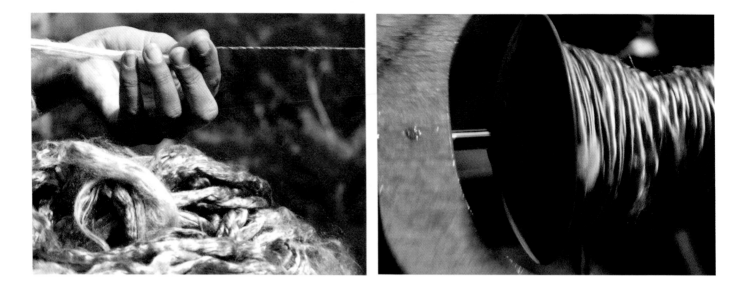

Adoring Rumpelstiltskin

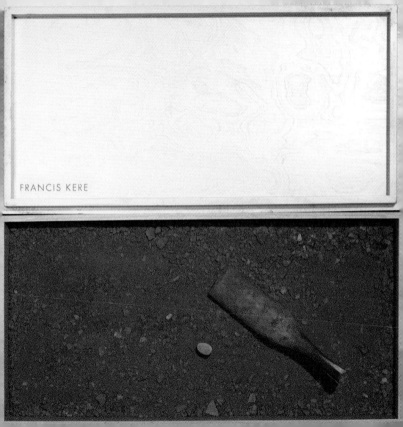

FRANCIS KERE

Francis Kéré

Berlin

Sandwich panels, one MDF board, earth, stone, wooden mallet from Burkina Faso.

Installation instructions: The box contains a structure made of sandwich panels, a wood board (MDF), a bag of earth, a stone, and a piece of wood. Cover the board with the earth and then put the two objects (the stone and the piece of wood) on top in order to make people understand what are the most characteristic objects in Burkina Faso.

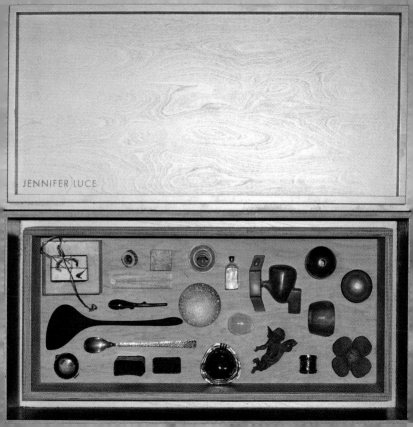

JENNIFER LUCE

Jennifer Luce

San Diego, California

"...TO HAVE AND TO HOLD"

Thirty-four objects from the Luce et Studio private collection, made by various artists dating from 1826 to 2011: one ceramic milk vase, one Ted Muehling egg vessel, one glass vial filled with "Naples" yellow pigment, one Venetian wood cherub, one Ryota Aoki "Tutu" vessel, one cast glass artist's muller, one John Goldsmith metal matchbox, one Birks Edwardian napkin ring, one Allan Adler Sunset Silver Pitcher Spoon, one florette from a historic Canadian building frieze, one Inuit children's tossing game, one Watkins & Hill ivory folding ruler, one engraved Victorian inkwell, one 1920s cigarette case from Moscow, one Japonesque meditation stone, one Sander Luske "lemonade cups," one ceramic milk vessel, one Dinosaur Designs cast resin bracelet, one metallic bowl from Japan, one octagonal ceramic vessel, one Glassybaby hand-blown glass votive, one glass perfume bottle, one Luce glass Pyrex vial, one opal stone, one optician's lens, one Yasha Butler ceramic bowl, one cherrywood spoon, one travertine artifact from the Getty Center, one Stefanie Hering ceramic vase, one Ted Muehling "Queen Anne's Lace" sterling silver tea strainer, one wax vase, one Luce solid acrylic block, one Tom Driscoll "Muse" series sculpture, one Ted Muehling red coral spoon, one vintage Murano glass ashtray.

I have always known that having beautiful, sensual things close by contributes a tremendous influence on our work as architects. Until now I had never had the occasion to ponder precisely what kinds of things we are drawn to. Collecting beauty always seemed to be an intuitive response, selecting a memory from a foreign voyage or collecting an object that inspires "form" for our next endeavor.

Answering your query as to what has inspired our creative process demanded some introspection. Of course we are inspired by art and literature and nature and science and culture, but what I had not acknowledged was the root of our *collecting* as an important ingredient in the mix—why we covet what we do.

It seems that en route we have gathered mostly vessels, delightful containers to *have* that metaphorically *hold* things safely. These vessels are reminders of what we aspire to make as architects, places to shelter, embrace, contain, and memorialize daily life.

Your crate is filled with our "valise," packed with our favorite collection of *containers*. We hope that you, Tod and Billie, enjoy touching,

162

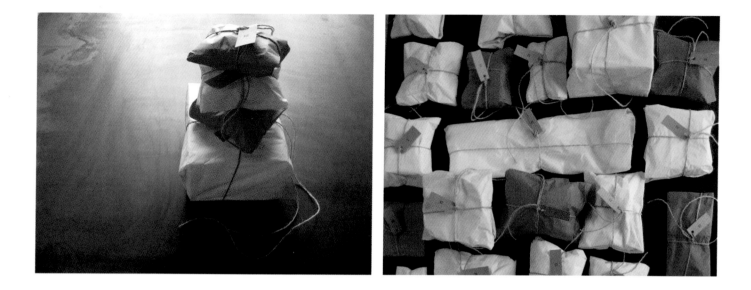

pondering, arranging. They are simply musings. Once arranged, they might spark memories or simply feel right together. There is a personal story to each for me . . . and now you, and Venice, will be a part of that history too.

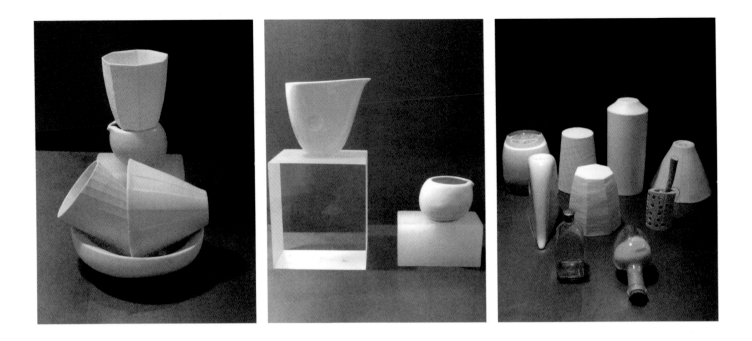

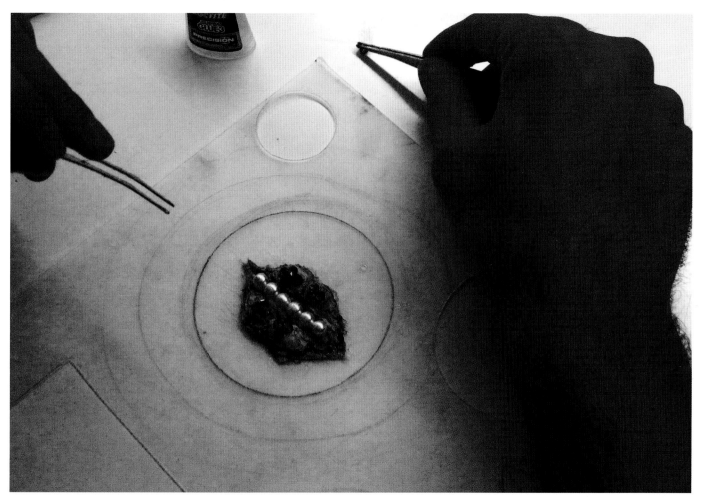

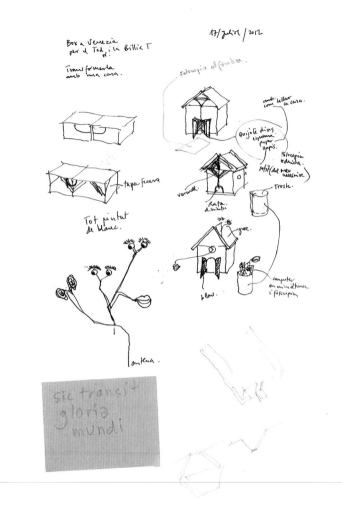

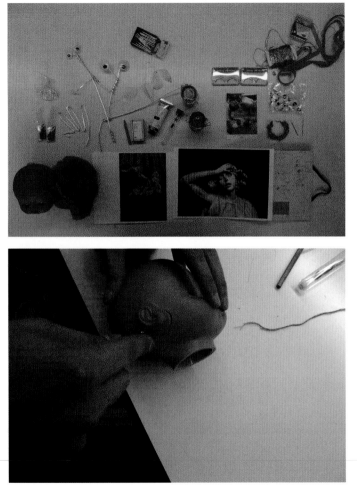

José Antonio Martínez Lapeña & Elías Torres

Barcelona

Various hinges, clips, magnets, strings, screws, and nails, twelve googly eyes, hand-shaped aluminum wire, IKEA pencil, aerial-shaped aluminum wire, four plastic eyelashes, four plastic ears, lips made from pearl and ruby beads, plastic supports, four cardboard mice with jewelry eyes, glass pot with 20 ml of olive oil, replica of Don Quixote book, drawing on foam core, doll's plastic eye, golden paper and blue acrylic paint on foam core, golden plastic laurel wreath, image of Bernini's Ecstasy of Santa Teresa and sculpture of an angel printed on foam core, plastic vial with two empty medicine capsules and one aspirin, image of José Antonio with two of his grandchildren printed on foam core.

The box transforms itself into a house and vice versa (so that the house can travel as a box).

Antennas on the roof:
Two pairs of eyes to see with; two pairs of ears to hear with; some ruby-red lips with pearly teeth to talk with.
A hand with pencil to improvise and survive with.

Door of the book:
Don Quixote for imagining, for being inspired, for taking risks, for learning about life.

Windows A, B, C, D:
A. Ephemeral glory ("sic transit gloria mundi"); crown of golden laurel leaves.
B/C. Headaches with aspirin/ecstasy with tablets.
D. Family home (children, protection, food): Els néts olive oil produced by José Antonio Martínez Lapeña.

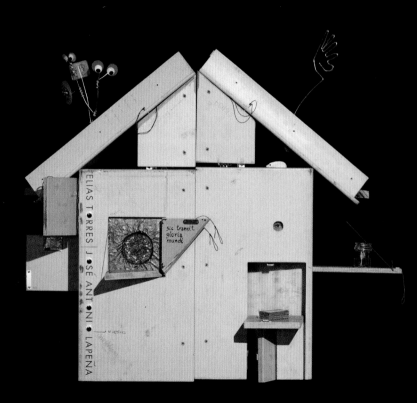

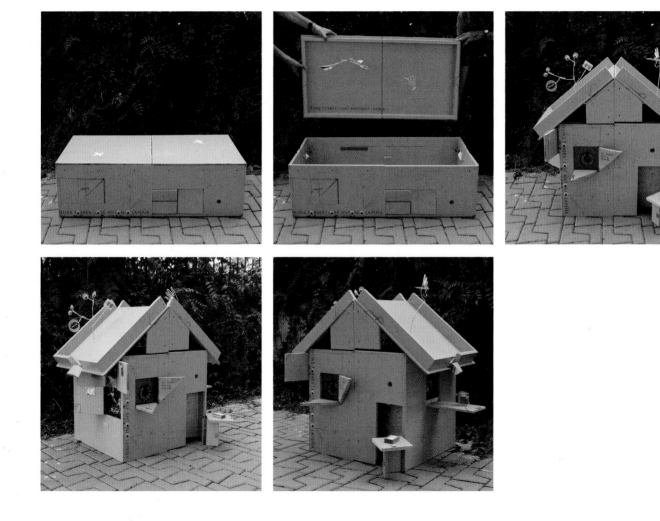

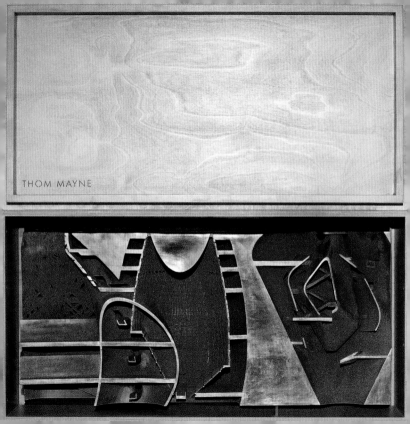

THOM MAYNE

Thom Mayne

Los Angeles

Featured in the model are "active" public spaces from seven Morphosis projects. These spaces, using their common function as atriums and stairways, are used as primitive geometries to carve the boundaries of the "site" in order to create voids. These voids connect and create linkages, inventing new spaces of interaction. The intent is to use the individual and unique "primitives" in order to reveal an inherent coherency in the overall scheme.

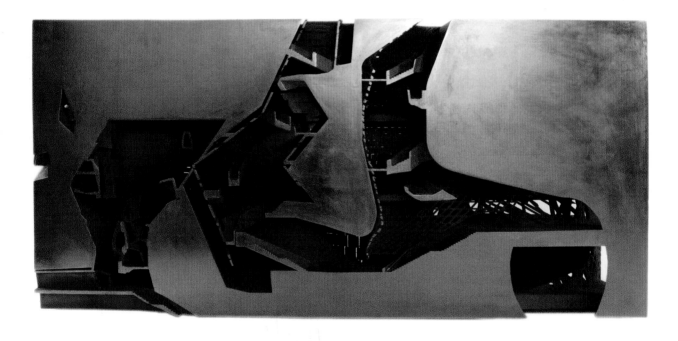

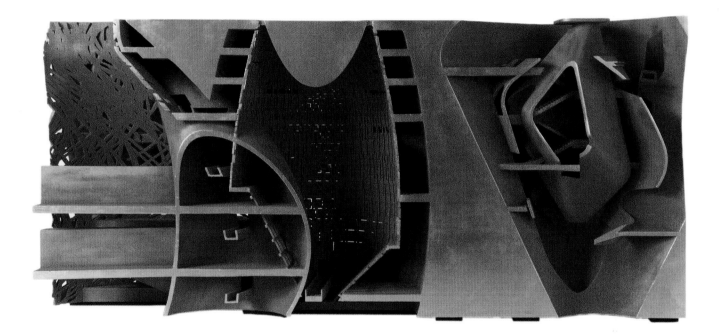

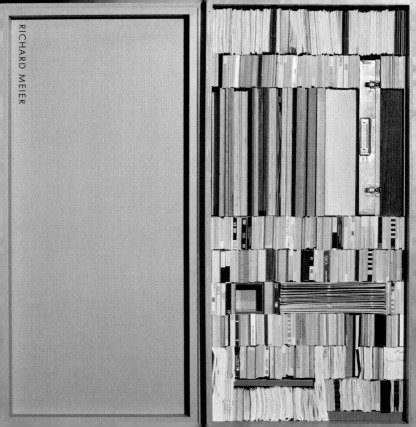

Richard Meier

New York City

Titled *Paraphernalia*, the concept depicts a time and place within the constructs of a working office of architecture. The items within have been translated from disregarded scraps to articles of progress, reconfigured to provide the viewer with a holistic and tangible visual experience. These devices of architecture work to encapsulate a moment in time, a place of reference, a process.

Paraphernalia

Three-dimensional mixed-media collage including printed and punched bond paper, full-size process drawing sets printed on bond, book publications, design magazines, metal slide box, basswood sheets (assorted thickness), $1/2 \times 1/4$ in. basswood lengths, $1/2$ in. double finished birch plywood, 4×4 in. cedar lumber, tongue and groove oak flooring segments, interior finishes sample pages, Letratone sheets.

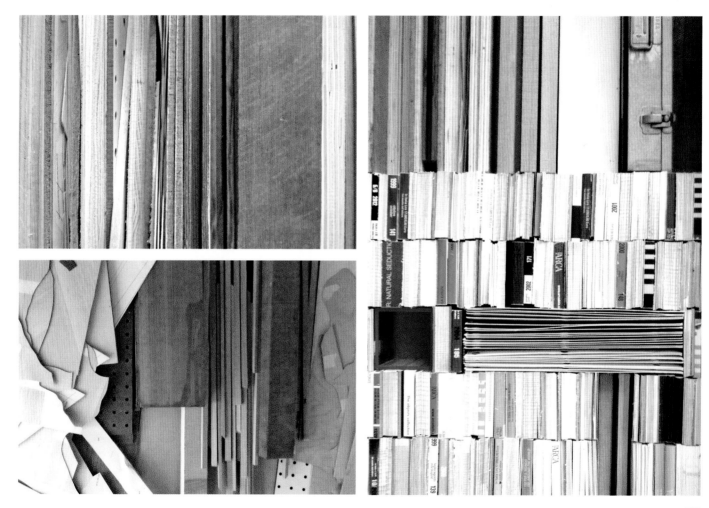

A domestic interior
even a palatial one
is in the end a box
where one takes refuge
and seeks privacy
in the cool shadows
whilst at the same time
yearning to flee - to dash outside
into the light.

This project was done in
collaboration with Paris-based
Korean artist, Heewon Kim.

Project Manager: Juan Garcia Mosqueda

Murray Moss

New York City

INSIDE-OUT

Photo by Heewon Kim mounted on panel, backlit by LEDs.

A domestic interior, even a palatial one, is in the end a box where one takes refuge and seeks privacy in the cool shadows while, at the same time, yearning to flee—to dash outside, into the light. This is my box.

Thinking: I thought to use the box as an architecture, and incorporate it into the piece, rather than just as a shipping container (a dual function). My narrative (as written above): when you are in a "box" (real or virtual/conceptual), you want desperately to get out, to flee through that beautiful door in Heewon's photo.

nestic interior
a palatial one
he end a box
one takes refuge
eeks privacy
cool shadows
at the same time
ng to flee - to dash outside
e light.

ject was done in
ation with Paris-based
artist, Heewon Kim.

Manager: Juan Garcia Mosqueda

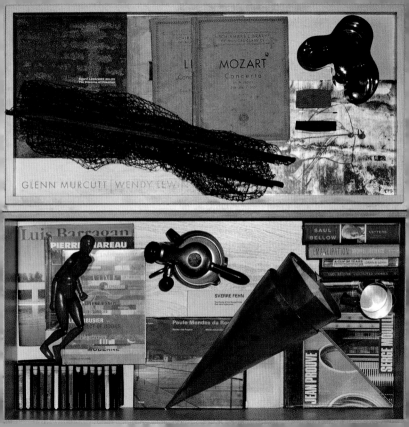

Sydney

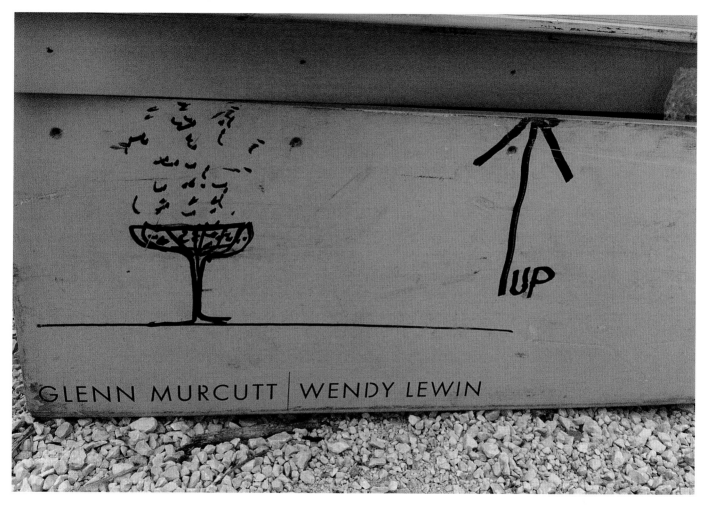

GLENN MURCUTT | WENDY LEWIN

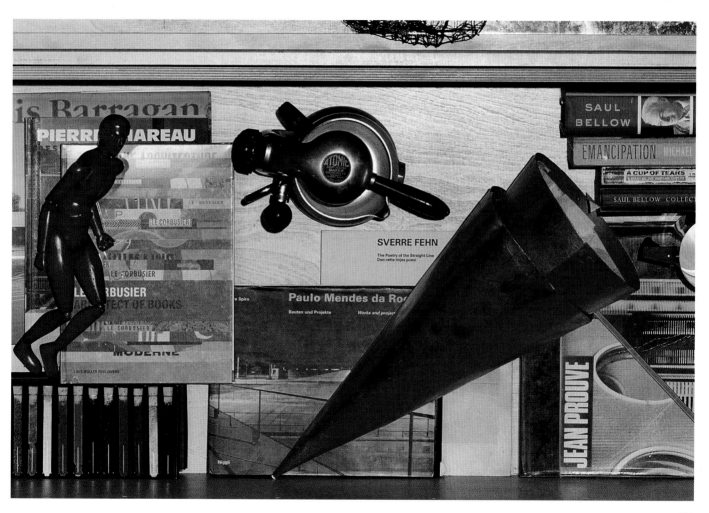

SHEILA O'DONNELL | JOHN TUOMEY

Sheila O'Donnell & John Tuomey

Dublin

Four scans of pencil-and-ink technical drawings, signed John O'Donnell, UCD School of Engineering, 1940; John Swimming, *watercolor, Sheila O'Donnell, 2009;* The Three Sisters, *scanned inkwash drawing, John Noel Tuomey, 1978;* Connemara Mountains, *watercolor, Sheila O'Donnell, 2003;* We'll heave a sigh and say goodbye to dear old Skibbereen . . . , *watercolor sketch, Sheila O'Donnell, 2009; gridded "eggcrate" insert made of 4 mm maple divided into twenty-seven rectangles, each approx. 105 × 154 × 100 mm, which form shelves when vertical; jagged perforated stone: gray eroded limestone from Burren, County Clare, Ireland; seven of Sheila O'Donnell's Sennelier sketchbooks, 1990s–2010; four paper model studies for Frankfurt Museum of World Culture competition, 2010; copy of Nolli Plan of Rome with colored lines describing routes taken, January 2012; two balls of twine from Madrid; three corked glass bottles of powdered pigment (yellow ochre, cobalt, burnt sienna) from Venice, 2004; one pair Staedtler dividers, circa 1940, John Noel Tuomey;* Tangled Up in Blue, *James*

It was a hard question that Tod and Billie asked.

How could we demonstrate how we think by filling a box with objects? We were challenged to make an installation that is not our professional work but that comprises *things that speak to you and the work you do.*

We like "things" and we like "boxes," so that was a start.

Things is such a versatile word: it embraces (useful) objects, words, ideas, books, images, experiences, personal belongings, undefined entities, landscapes . . .

We are always thinking about places and landscapes, culture, use, time and layers (new on old, concrete on stone). Each project has its brief and site. These are particular and explicit, and we immerse ourselves in them and start every project afresh and from the beginning in response to place and brief. But there are certain constants that provide continuity in our work.

We have an interest in presence, character, and identity, in purpose and usefulness, in time, memory, and tradition.

We are inspired by objects and artifacts of useful beauty. We like when they carry the marks of wear and weather, of use and pressure.

Tuomey, 2003; *sterling silver and cowhide earring, Rebecca Lett, 2007; plaster cat, Eimear Walsh, 2010;* There must be some way out of here said the Joker to the Thief, *James Tuomey, 2003;* John's Potato, *watercolor, Sheila O'Donnell; broken toy car convertible, 1953 model; fragment of sheep bone with lichen from dunes at Carrigskeewaun, County Mayo, Ireland, from Paul Keogh to John Tuomey;* Greek Wheelbarrow, *watercolor, Sheila O'Donnell, 2012; triangular stone, red and white stone, Halki, Greece; angled stone, storm beach, Roundstone, County Galway, Ireland; chapels in Halki, Greece, watercolor, Sheila O'Donnell, 2012; limestone with spiral fossil from County Clare; forty-five Sennelier chalk pastels; angled gray stone from West of Ireland; brown and clear glass bottles, dug up in garden in Dublin 1983; rusty steel ring; scanned drawing from* Done, Said, Redone, *Daniel Tuomey, 2012;* Rhodes + Nissos, *watercolor, Sheila O'Donnell, 2010; dried thistle head;* Teampall Bheanain, Árainn, *watercolor, Sheila O'Donnell; faceted green beach stone, Hydra, Greece, found 2012; small rounded stone (limestone) with holes; rounded spotted fossil stone, rounded stone with white cross, and two rounded stones with holes and spots, Burren, County Clare, found 1990s; four carved wooden ink stamps from Venezuela, 1992; porcelain paint mixing tray with small colored shells from Moyrus Beach, Connemara, collected 2004;* Morning Light and Shadow on Halki Mountain, *watercolor, Sheila O'Donnell, 2012; seawashed glass (mermaid's nipple); pottery fragment, Pefkia, Halki, Greece; pink granite stone with human shape from Inislacken, Bertrabui Bay, County Galway, found 2005; Japanese wooden bowl with colored stones from Halki and Hydra, Greece, found 2010; Jim Stirling's woolen tie; painted, chipped folding Greek chair signed A π (Antonis Patras), 1990;* Finis, *watercolor, Sheila O'Donnell, 2008;* The Light Came in the Window, *watercolor, Sheila O'Donnell; 2011,* John in Connemara with the Greek Chair, *three black-and-white photographs.*

We refer to topography—landscapes worked and formed into steps, platforms, and walls, which are both circulation and place and which effortlessly negotiate changes in level and direction.

Words are among the things which motivate us most powerfully. Arrangements of words, like the careful grouping of stones consciously and critically selected on a beach in Greece or Connemara.

We thought about representing words and ideas in the box by including significant books and texts, but this did not seem precise or focused enough. The books would be closed, the texts not legible.

We decided to use physical objects and images to speak for us. In our box we put those edited stones and shells, crafted functional artifacts, pigments and tools of our trade, souvenirs, keepsakes, chapels, shrines, and landscapes represented by maps and sketches. These are objects which have been transformed into things through use or observation or our active appropriation.

Nolli's map of Rome overlaid with colored lines recalls walks and conversations and Baroque interiors threaded like strings through the city.

Our box comprises three layers.

1. Attached to the base of the box are drawings made by our fathers: John O'Donnell's precise pencil-and-ink engineering student's drawings made in 1940, Jack Tuomey's sketches of his native Kerry landscape. Our background.
2. A maple grid is inserted in the middle layer. This holds objects and images of inspiration and significance, and partly obscures our fathers' drawings. These can be glimpsed through artworks and sketches made by our sons, Jim Stirling's tie, Irish stones in a Japanese turned bowl, natural and crafted objects, things collected and recorded over many years.
3. Bolted inside the lid of the box is a simple folding chair with layers of chipped blue paint and the initials of the Greek islander who gave it to us, and a new layer of rust stains from west-of-Ireland winters.

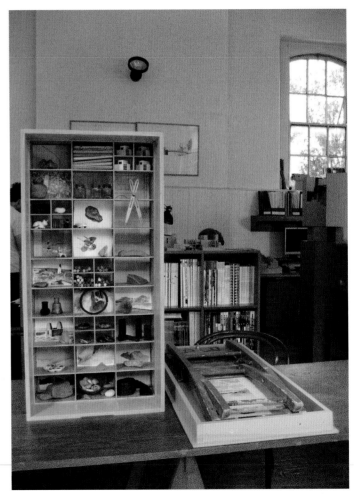

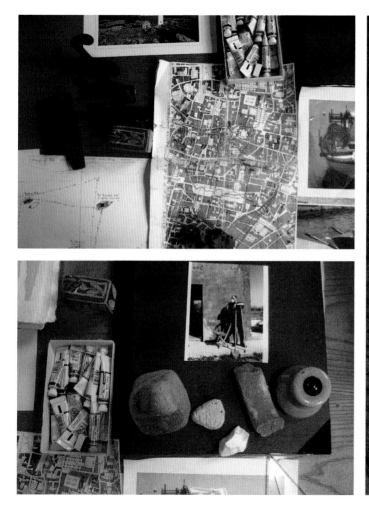

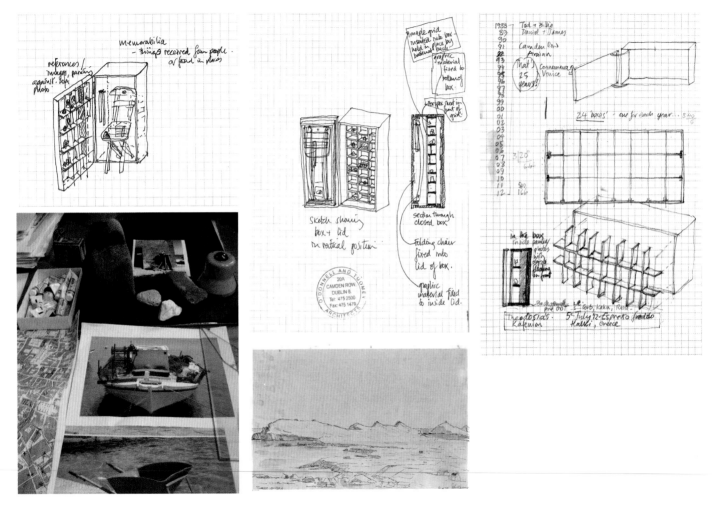

Memorabilia
— things received from people
or found in places

references/
makings, painting
against tape
photo

sketch showing
box + lid
on vertical position

O'DONNELL AND TUOMEY
20A
CAMDEN ROW,
DUBLIN 8.
Tel: 475 2500
Fax: 475 1479
ARCHITECTS

simple grid
inserted into box,
held in place by
battens/rack

graphic
material
fixed to
bottom of
box

horizon sheet in
front of grid

section through
closed box

Folding chair
fixed into
lid of box.

graphic
material fixed
to inside lid.

1988 — Tod + Billie
89 — Daniel + James
90
91 — Camden Row
92 — Arawin
93 That — Connemara
94 25 Venice
95 years!
96
97
98
99
00
01
02
03
04
05
06
07 3/20
08 6/60
09
10 500,
11 11/60
12

24 boxes — one for each year... 840

in the box
inside panels
photos
with
acrylic
glazing
on front

Theodosia's
Kafenion

5th July 12 - Espresso freddo
Halki, Greece

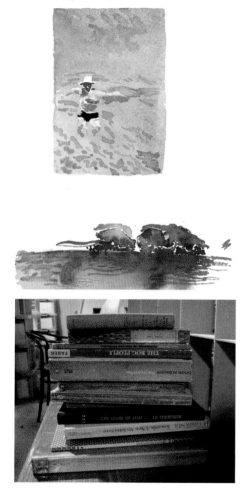

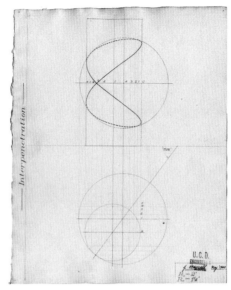

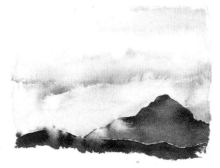

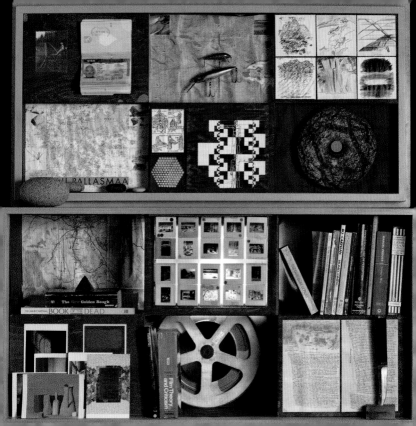

Juhani Pallasmaa

Helsinki

MEMORY BOX

Mixed media, including fragments of three maps (Egypt, Lapland, Archipelago of the Gulf of Finland), two used fishing lures, a used film reel, Tapio Wirkkala's sheath knife, my old invalidated passport, pyramid made of semiprecious stone, two loaves of rye bread, four stones rounded by water, twelve art postcards, ten photocopies of my travel sketches, twenty original color slides from my travels, two photocopies of a letter of Tapio Wirkkala to me, laminated glass sheet (100 × 50 cm, 5 mm thickness), lightbulb and cord. And fourteen books: THE DIALOGUES OF PLATO; LETTERS TO A YOUNG POET, *Rainer Maria Rilke;* THE POETICS OF SPACE, *Gaston Bachelard;* HOMECOMING, *Bo Carpelan;* LABYRINTHS, *Jorge Luis Borges;* WATERMARK, *Joseph Brodsky;* PHENOMENOLOGY OF PERCEPTION, *Maurice Merleau-Ponty;* THE FLAME OF A CANDLE, *Gaston Bachelard;* IN SEARCH OF LOST TIME: SWANN'S WAY, *Marcel Proust;* LESS THAN ONE, *Joseph Brodsky;* THE GOLDEN BOUGH: BOOK OF THE DEAD, *Sir James Frazer;* SCULPTING IN TIME, *Andrei Tarkovsky;* FILM THEORY AND CRITICISM, *Mast & Cohen.*

Designing, making art, and writing are ways of working on one's memories and experiences as well as on one's sense of self. Each new work is an effort to redefine one's situation in the world of experiences. Ideas emerge in a diffuse and seemingly arbitrary manner from travels near and far, human encounters, books, works of art, miracles of nature, films, dreams and daydreams, experiences of life and previous work, moments of happiness and anxiety, forebodings and uncertainties. The epic scope of life is the true ground of every creative endeavor. Most often it is impossible to identify a single source of inspiration, as thoughts and emotions arise from the embodied and merged entity of all the experiences that have accumulated in one's sense of the world, temporal continuum and self. They are memories that have turned

into one's flesh, and they are not any more identifiable. As long as the impulses remain direct, focused, and nameable, they have not fully dissolved into the creative entity, with its own anatomy, independence, and self-sufficient existence. The mind advances autonomously along unpredictable paths, and a poetic discovery is always familiar and novel, comforting and disturbing, at the same time.

I personally keep working on my various projects in design, writing, and artistic experimentation in order to find out, time and again, who I am and what is my niche in the continuum of life and experience. This is a slow and gradual process that resembles crawling in the dark or molding a huge and shapeless lump of matter, the stuff of which is a

conglomerate of the world and myself—"the flesh of the world," to use a notion of Merleau-Ponty.

The *Memory Box* surfaces some of the recurring ingredients of my repeated investigations of my understanding of the self, its constituents, layered historicity, and intertwining with what surrounds and precedes me. It collages the trajectory of a shy Finnish boy who spent his childhood during the war years at his grandfather's humble farm, was pulled to wider circles, and eventually turned into a Citizen of the World. However, I am constantly reminded of the beginning of my journey, and those recollections motivate and inspire me more than anything else.

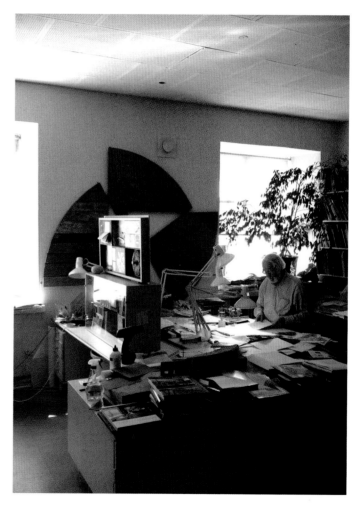

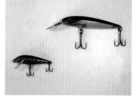

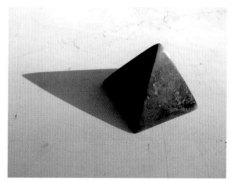

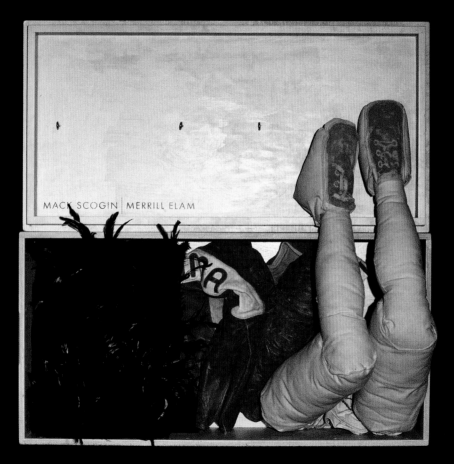

MACK SCOGIN | MERRILL ELAM

Mack Scogin & Merrill Elam

Atlanta

LEATHERS, FEATHERS, AND LEGS

Leather with brass fittings and nylon interlayer, Georgia red clay dust; feathers on cashmere, silk buttons and trim; canvas filled with cotton, photo transfer, twine.

Architecture is an extraordinarily inclusive discipline where the common becomes the exceptional through rigor, intuition, criticism, paradox, and principled expectations. The architect is the soul of the discipline. If there is no soul, there is no architecture. Architects get here by testing personal limits, expanding societal boundaries, embracing discomforting differences, suspending judgment, and celebrating the humane. Experience, talent, and intellect are not enough in this realm. The things architects do and how they think are what define their work in architecture.

The leathers are from Mack's last motorcycle race in 1984. The black coque-feathered wrap was designed by Merrill in 2008 and was worn only once. The mannequin legs/person represents the many amazing young people we are privileged to work with in architecture. Their talent, intelligence, and dedication inspire us in all that we do.

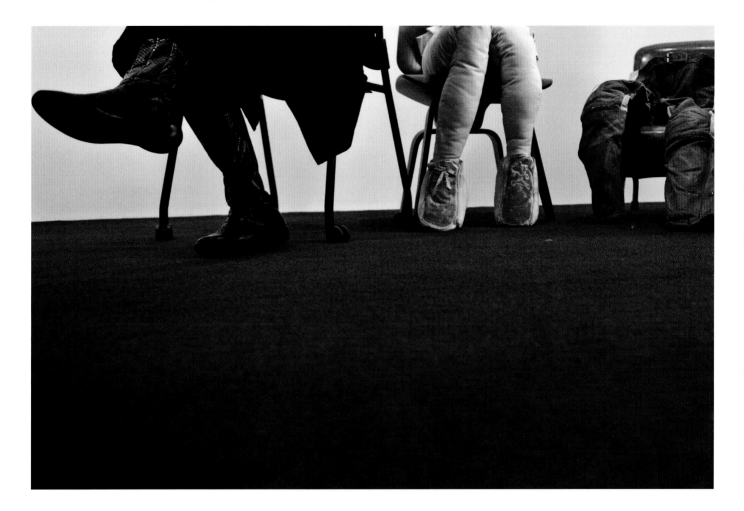

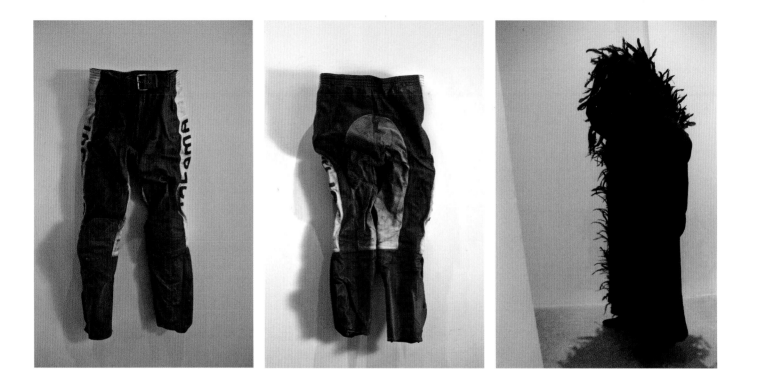

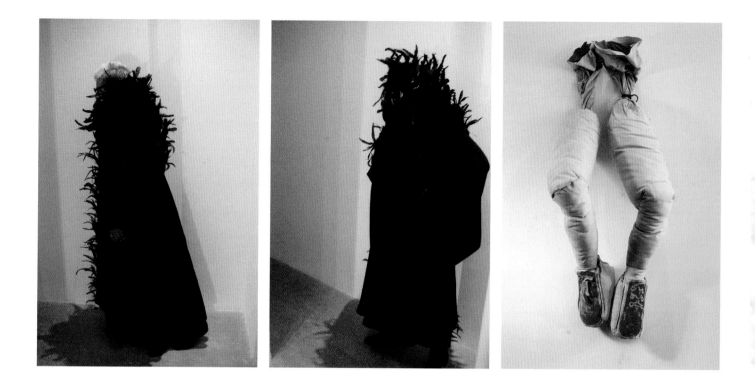

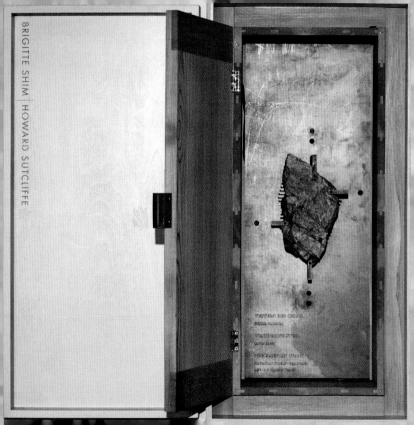

Brigitte Shim & Howard Sutcliffe

Toronto

TOOLBOX OF THE SENSES

Weathering steel (ASTM A588), Precambrian granite (Canadian Shield feldspar), western red cedar (Thuja plicata), and electrical sound equipment.

Each element in our *Toolbox of the Senses* was selected to heighten our senses of touch, smell, and sound. Each element has a trace of the postglacial landscape embedded in the Precambrian Canadian Shield, where geological time is evident and all encompassing.

When one opens the door to the *Toolbox of the Senses,* you are immediately transported by sound into a small boat traveling from the mainland to a remote island. The visitor arrives at a dock, then begins the auditory journey on a wooden boardwalk through architectural spaces that one can experience by smell and touch. The visual is conjured through memory and imagination.

Inside the *Toolbox of the Senses* you can run your hands across a granite rock that is over a billion years old and smell the rich aroma of cedar and listen to the soundscape of a physical journey through spaces that oscillate between inside and outside.

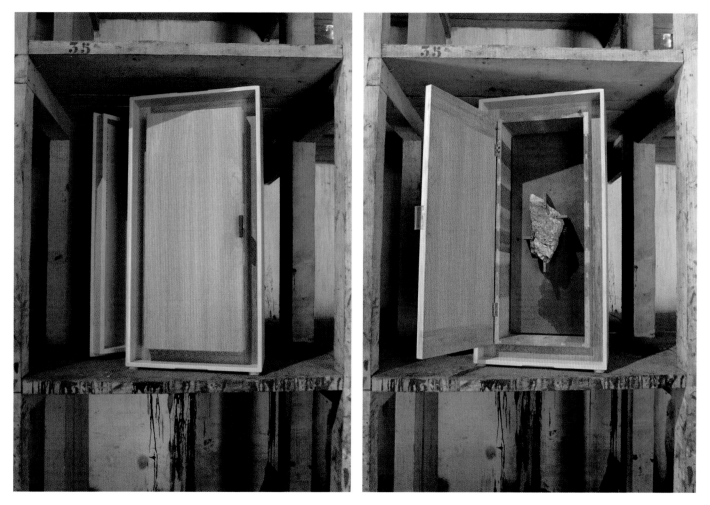

217

Venice Box

$18^{3/4}"$

$5 \frac{1}{8}$

$38 \frac{7}{8}"$

$2^{\frac{1}{4}}"$

$10^{7/8}"$

wire
Ulass

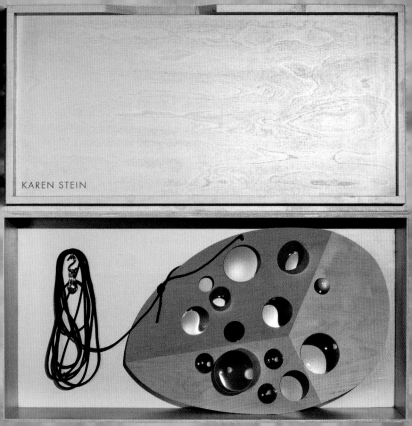

Karen Stein

New York City

LOOK

Plywood, magnifying lenses, rope.

As you know, my medium of choice is words, so filling this box has been a bit daunting, to say the least. You asked each of us to fill it with something that demonstrates how we think and to show what moves us and what motivates the work that we do. After considerable fretting, I decided I wanted to make a looking glass of sorts—not something to admire yourself in, but, rather, a device to help study things in greater detail. As I've said, fascination with things outside my immediate province is what attracted me to architecture in the first place. So I bought a bunch of magnifying glasses with different size lenses and different magnifications. They are now assembled in this faceted plywood form that is somewhere between a shield and a Venetian carnival mask. It needed a name for the customs declaration form, so I'm calling it *LOOK*.

Ideally the piece would hang somewhere out in the open, with a good vantage point on the contents of other boxes. My box could be used for exhibition visitors to stand on so that they can peer through the thing, hopefully getting a closer or different vantage point on something compelling nearby. And, if this thing works at all (and the piece is not destroyed in transit or in use), *LOOK* will be helping people to do just that, surrounded by architects and their work, which is, in essence, what I do on a daily basis.

See you soon,
Karen

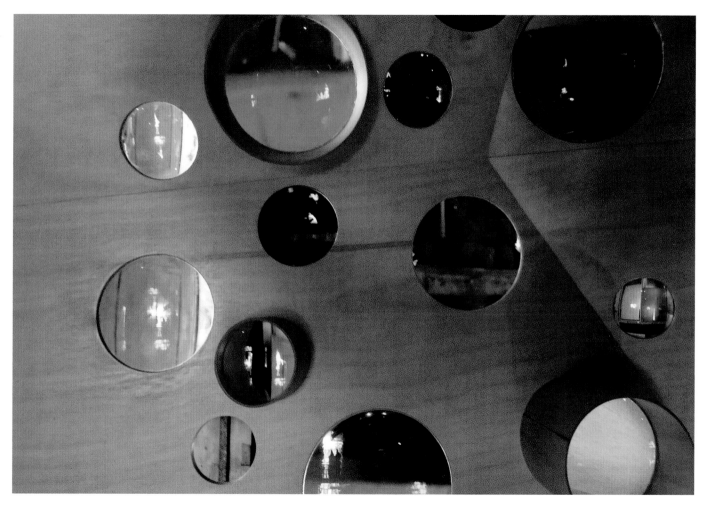

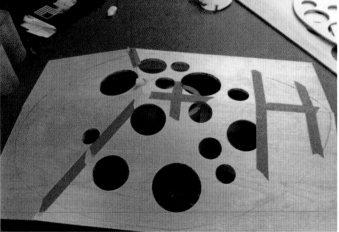

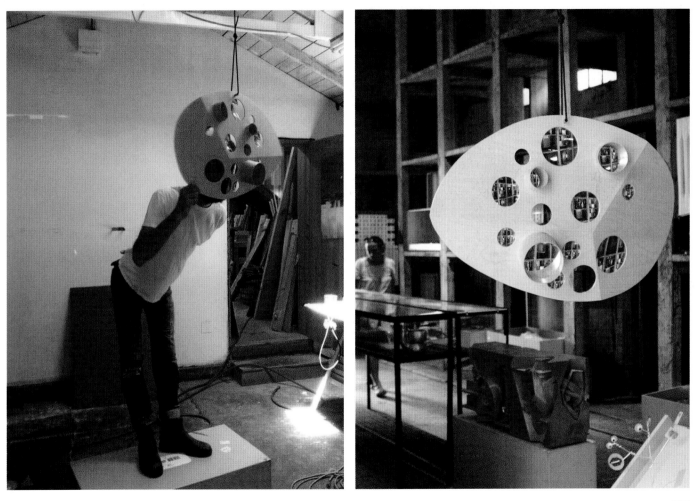

URSULA VON RYDINGSVARD

Ursula von Rydingsvard

Brooklyn, New York

Hopscotch Rectangle (Hemorrhaging Cedar)

Hopscotch Rectangle. *Cedar, graphite, and charcoal.*
Hemorrhaging Cedar. *Cast abaca paper.*

When the Stephen Iino box first arrived, I racked my brain to think of a dynamic piece that I could make which could fit into this little box. I have a great deal of difficulty making domestic-scale sculptures, as it seems that large-scale pieces often come closer to saying what I need to say, with their complicated crevices and jagged, sometimes sliding edges. With large sculpture I get thousands of opportunities to make decisions about the lean, the energy, and the anxiety of the sculpture.

After dismissing the little box as an impossibility for me, the thought entered my mind of using paper, and I rejoiced at how many layers I could stack in that box . . . I could achieve a scale closer to my needs—that is, large scale but an almost invisible depth.

I proceeded by making a relief sculpture out of cedar that measured exactly 139 inches tall, 52 inches wide, and 2 inches deep. I cut this cedar relief into exactly 33 equal rectangles. I proceeded to cover each of the sections with a special handmade paper called abaca, which comes from a rare banana stem from the Philippines that is whipped into pulp. I coaxed the wet paper into the crevices of each of the 33 cedar surfaces, let the paper dry, then peeled it off. Each of the frames was

reinforced with additional abaca paper and methyl cellulose glue. I then clipped the rectangular frames together from the back and hung it, all 12 feet of it. And yes, all 33 rectangles fit into one another perfectly and into the gray box. The astonishing thing that became evident—the big surprise—was that this paper while it was drying had the ability to suck the color out of the cedar, making geographical blotter forms ranging from earth colors to a more intense alizarin crimson. My intention was to knock the socks off of Billie and Tod with the piece I would submit, but alas, *Hemorrhaging Cedar* never made it to the Venice Biennale because it was too fragile.

I ended by making another sculpture using a material that I knew well, cedar (I've been using it for thirty-five years). I made an organic stacking of cedar from smaller to more voluptuous by cutting the ends of 4 × 4 inch cedar beams and stacking them one on top of the other. I built them in the box, making sure that there was a kind of tension between the grid of the stacked 4 × 4s and their organic wandering spilling over the carved ends of the cedar beams.

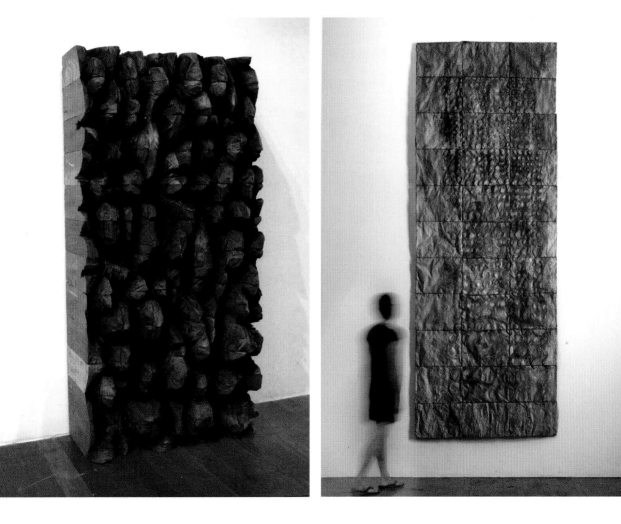

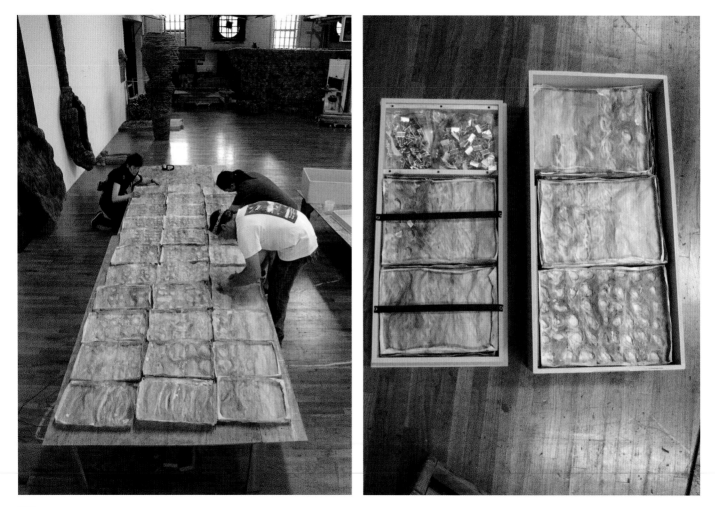

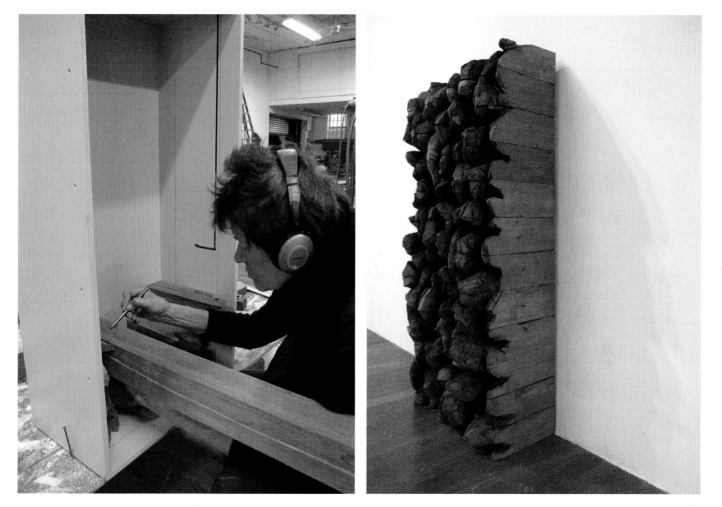

PETER ZUMTHOR

Peter Zumthor

Haldenstein, Switzerland

Thirty color pigments in glass jars.

I love color pigments; pure color, pure material. Color as material.

I asked Barbara and Gaelle to go to our model workshop and select some color pigments and related materials. They brought up a selection and put them on the overturned transport case for me to see. This is what you're looking at; nothing has been changed.

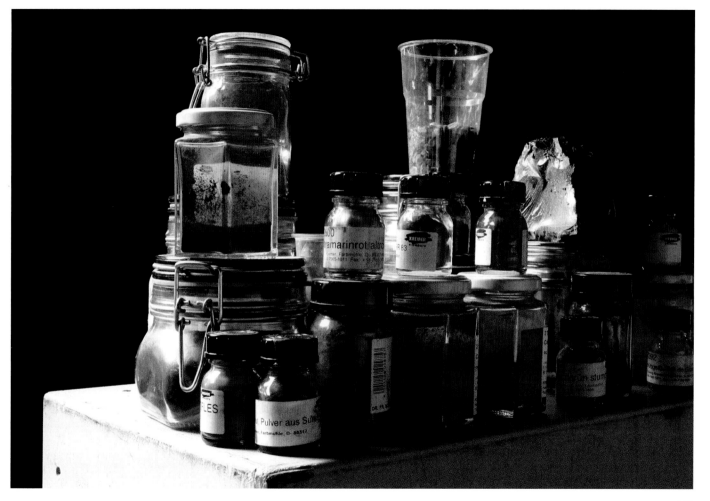

Contributors

TOD WILLIAMS AND BILLIE TSIEN have worked together since 1977. Williams received his bachelor's degree and master of fine arts and architecture from Princeton University. Tsien received a bachelor of fine arts from Yale University and a master of architecture from the University of California at Los Angeles. In 1986 they formed Tod Williams Billie Tsien Architects in New York City. Williams and Tsien also teach and lecture worldwide.

MARWAN AL-SAYED received a master of architecture from Columbia University. He worked with Williams and Tsien for nine years, then formed Marwan Al-Sayed Inc. Architecture + Design in Phoenix, Arizona. In 2012 he relocated the firm to the Los Angeles area.
Project acknowledgments: Marwan Al-Sayed Inc. Architecture + Design, Gabby Quijada, Mies Grybaitis, Carrie Bloomston

ANTHONY AMES received a bachelor's degree from Georgia Tech and his master's degree from Harvard University. In 1974 he founded Anthony Ames Architect in Atlanta. He is a fellow of the American Institute of Architects and of the American Academy in Rome.
Project acknowledgments: Anthony Ames Architect, Clark Tefft

MATTHEW BAIRD received a bachelor's degree in architecture from Princeton University and a master of architecture from Columbia University. Baird joined Tod Williams Billie Tsien Architects in 1992. Ten years later he started his own firm, Matthew Baird Architects, in New York City. He has taught at Yale University, Rhode Island School of Design, and Parsons School of Design.
Project acknowledgments: Amee Allsop, Teresa Ball, Maria Milans del Bosch, Frank Chirico, Tucker Douglas, Hernan Garcia, Erica Goetz, Bradley Kaye, Cassie Spieler, Juanita Wichienkuer, Hannah Wilentz, Rushyan Yen

SHIGERU BAN attended the Southern California Institute of Architecture and graduated from Cooper Union School of Architecture. In 1985 he established Shigeru Ban Architects in Tokyo. He has taught at Keio University, Harvard University, Cornell University, and Kyoto University of Art and Design.
Project acknowledgments: Shigeru Ban Architects

MARLON BLACKWELL received a bachelor's degree from Auburn University and a master of architecture from Syracuse University in Florence, Italy. He has led Marlon Blackwell Architect, based in Fayetteville, Arkansas, since its inception in 1990 and heads the Fay Jones School of Architecture at the University of Arkansas.
Project acknowledgments: Marlon Blackwell Architect; text with David Buege; Johnny Cash photograph © Jim Marshall Photography LLC; barn photograph © Jake Rjas; additional photography by Justin Hershberger, William Burks

WILL BRUDER received a bachelor of fine arts degree in sculpture at the University of Wisconsin, Milwaukee. Bruder apprenticed with Gunnar Birkerts and Paolo Soleri before obtaining registration as an architect. He opened his studio, Will Bruder Architects, in Phoenix in 1974.
Project acknowledgments: Will Bruder Architects

WENDELL BURNETTE is principal of Wendell Burnette Architects (WBA), which he established in 1996 after a three-year period at the Frank Lloyd Wright School of Architecture and an eleven-year association with Will Bruder. He is a professor at Arizona State University.
Project acknowledgments: Wendell Burnette Architects, Metalworks, Inc.

JOHAN CELSING is principal of Johan Celsing Arkitektkontor in Stockholm. He also teaches at KTH the Royal Institute of Technology, Stockholm. In 2010 he was elected as a member of The Royal Swedish Academy of Sciences.
Project acknowledgments: Johan Celsing Arkitektkontor, photos © Ioana Marinescu

CHEN CHEN AND KAI WILLIAMS studied industrial design at Pratt Institute. Their design studio, founded in 2011, is in Greenpoint, Brooklyn. Their work has been shown in New York, Miami, and São Paulo.
Project acknowledgments: Photos by Michael Moran

TARYN CHRISTOFF AND MARTIN FINIO are founding partners in the New York–based Christoff:Finio Architecture. Christoff received a bachelor's degree from the Illinois Institute of Technology in 1984. Finio is a 1988 graduate of the Cooper Union School of Architecture. Finio worked for Tod Williams and Billie Tsien from 1990 to 1999.
Project acknowledgments: Christoff:Finio Architecture, Ed Johan, Steve Lampasona, Brett Appel, Thomas Ryan, Anne Herndon, Melissa Cataldo

ANNIE CHU AND RICK GOODING are principals of Chu + Gooding Architects in Los Angeles. They studied at SCI Arc and Columbia University. Both worked with Tod Williams and Billie Tsien in the 1980s. Chu teaches at Woodbury University, and Gooding's drawings are part of the online viewing program of The Drawing Center.
Project acknowledgments: Chu + Gooding Architects, Wendy Lau; fabrication by Yoshi Morohashi; finishing by Frank Vaccaro/Dura Strip

WG CLARK studied architecture at the University of Virginia. In 1974, Clark formed WG Clark Architects which is now based in Charlottesville. He has been the Edmund Schureman Campbell Professor of Architecture at the University of Virginia since 1989.
Project acknowledgments: Photos by Sarah Sargent

BRAD CLOEPFIL attended the University of Oregon and received a master of architecture from Columbia University. In 1994 he founded Allied Works Architecture, with offices in Portland and New York. Cloepfil has held guest professorships and has lectured throughout North America and Europe.
Project acknowledgments: Allied Works Architecture, Keith Anlwick, Sarah Royalty, Conner Bryan, Robert Slattery

ELIZABETH DILLER, RICARDO SCOFIDIO, AND CHARLES RENFRO lead Diller Scofidio + Renfro, based in New York City. Diller received a bachelor of architecture from the Cooper Union School of Architecture and is a professor of architecture at Princeton University. Scofidio attended the Cooper Union School of Architecture and received a bachelor of architecture from Columbia University. He is professor emeritus of architecture at the Cooper Union School of Architecture. Renfro, who attended Rice University and received a master of architecture from Columbia University, became a partner in 2004. Renfro is a visiting professor at Parsons New School for Design.
Project acknowledgments: Diller Scofidio + Renfro, J. D. Messick, Louis Lipson, Emily Vo Nguyen

PETER EISENMAN is principal of Eisenman Architects, founded in New York in 1980. He received a bachelor of architecture from Cornell University; a master of architecture from Columbia University; and master's and doctoral degrees from the University of Cambridge. He is professor emeritus at the Cooper Union School of Architecture, and he teaches at Yale University.
Project acknowledgments: Eisenman Architects, William Smith

STEVEN HOLL graduated from the University of Washington and studied architecture in Rome and at the Architectural Association in London. In 1976 he established Steven Holl Architects in New York City. Holl is a professor at Columbia University.
Project acknowledgments: Steven Holl Architects, Garrick Ambrose, Janine Biunno, Xi Chen

STEPHEN IINO lives with his wife and son in New York City. He makes things for people in his shop in Paterson, N.J.
Project acknowledgments: Photos by Kenneth B. Gore

TOYO ITO graduated from the University of Tokyo's department of architecture and established an office in Tokyo in 1971. He received the Pritzker Architecture Prize in 2013.
Project acknowledgments: Toyo Ito & Associates, Architects

BIJOY JAIN received a master of architecture from Washington University in St. Louis and worked in Los Angeles and London before returning to his native India in 1995 to found his architectural practice Studio Mumbai.
Project acknowledgments: Studio Mumbai Architects

CLAUDY JONGSTRA graduated from the Academy of Art in Utrecht. Since 1994 she has worked as an artist in Spannum, the Netherlands, creating tapestries and large-scale textile art installations with natural materials.
Project acknowledgments: Studio Claudy Jongstra

FRANCIS KÉRÉ was born in Gando, a small village in Burkina Faso. He studied architecture at the Technical University of Berlin, graduating in 2004. In 2005 he founded Kéré Architecture in Berlin.
Project acknowledgments: Kéré Architecture, photo by Erik-Jan Ouwerkerk

JENNIFER LUCE is principal and founder of Luce et Studio Architects in La Jolla, California. Luce studied architecture at Carleton University and received a master of design studies from Harvard University.
Project acknowledgments: Luce et Studio Architects

José Antonio Martínez Lapeña and Elías Torres graduated from Escola Tecnica Superior de Arquitectura de Barcelona and in 1968 opened their architectural practice in Barcelona. Martínez Lapeña is a professor at ETSA Barcelona, ETSA Vallés, ETSA Ramón Llull, and ETSA Pamplona. Torres is a professor at ETSA Barcelona and has taught at UCLA, Harvard University, and the University of Virginia.
Project acknowledgments: Martínez Lapeña Torres Architects, Borja Gutiérrez, Laura Jiménez, Marc Marí, Aureli Mora, Adrià Orriols, Roger Panadès, José Sanmartín, Yoshihiko Takeuchi

Thom Mayne was educated at the University of Southern California and Harvard University. In 1972 he founded Morphosis Architects in Santa Monica, California. Mayne received the Pritzker Architecture Prize in 2005.
Project acknowledgments: Morphosis Architects, Edmund Ming Yip Kwong, Benjamin Salance, photos by Dan Wilby

Richard Meier studied architecture at Cornell University and established his office in New York City in 1963. Today Richard Meier & Partners Architects has offices in New York and Los Angeles. Meier has taught at the Cooper Union School of Architecture, Princeton University, Pratt Institute, Harvard University, Yale University, and the University of California at Los Angeles. In 1984 Meier received the Pritzker Architecture Prize.
Project acknowledgments: Kevin R. Browning

Murray Moss is the creative mind behind the Moss design gallery in New York, which he founded in 1994. In February 2012, Murray closed his store and inaugurated Moss Bureau, a design consultancy firm.
Project acknowledgments: Juan Garcia Mosqueda, photo by Heewon Kim

Glenn Murcutt and Wendy Lewin practice architecture in Mosman, Australia. Murcutt received a diploma of architecture from the University of New South Wales Technical College, and in 1969 he established his own practice. He received the Pritzker Architecture Prize in 2002. Lewin, to whom Murcutt is married, obtained her architecture degree from the University of Sydney and established a private firm in 1993. She has taught at the University of Sydney, University of New South Wales, and Hong Kong University.

Sheila O'Donnell and John Tuomey established O'Donnell + Tuomey Architects in Dublin in 1988. In 2008 they opened an office in Cork. They lecture at the University College Dublin and have taught throughout the U.S. and U.K.
Project acknowledgments: O'Donnell + Tuomey Architects

Juhani Pallasmaa is a Finnish architect, educator, and critic. He has been working in architecture and in product, exhibition, and graphic design since the early 1960s with his Helsinki-based practice Arkkitehtitoimisto Juhani Pallasmaa KY. He has been rector of the Institute of Design Helsinki, director of the Museum of Finnish Architecture, and professor and dean of the faculty of architecture at Helsinki University of Technology.
Project acknowledgments: Arkkitehtitoimisto Juhani Pallasmaa KY

Mack Scogin and Merrill Elam are principals of Mack Scogin Merrill Elam Architects in Atlanta. Both earned their bachelor of architecture degrees from the Georgia Institute of Technology. Scogin is the Kajima Professor in Practice of Architecture at Harvard University. Elam lectures and teaches at the University of Toronto, Ohio State University, and Yale University.
Project acknowledgments: Mack Scogin Merrill Elam Architects; leathers made by JOFAMA; feathers made by Knox Clayton with Merrill Elam; legs made by Margee Benning Bright

Brigitte Shim and Howard Sutcliffe formed Shim-Sutcliffe Architects in Toronto in 1994. Both received degrees in environmental studies and architecture from the University of Waterloo. In 2012 they were awarded the Order of Canada in the field of architecture.
Project acknowledgments: James Chavel, Andrew Hart, and Ryan Beecroft; soundscape by Q-Media Solutions; box interior by Two Degrees North; electronics by DeRock Electric; steelwork by Tremonte Ironworks; laser cutting and machining by Design AG Inc.

Karen Stein is a critic, an architectural advisor, the executive director of the George Nelson Foundation, and a faculty member of the design criticism program at the School of Visual Arts in New York. She served as a jury member of the Pritzker Architecture Prize from 2003 to 2012.
Project acknowledgments: Jeff Jamieson, Kyle Wilhelm, photos by Deborah Denker